IMAGES
of America

POINT CABRILLO
LIGHT STATION

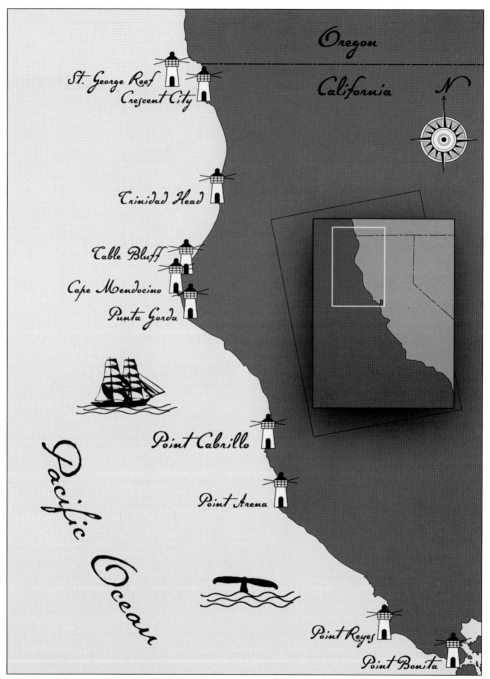

This map of the north coast of California shows the relation of the lighthouses to Point Cabrillo. (Courtesy Nan Walter.)

ON THE COVER: The senior assistant keeper's house at Point Cabrillo Light Station is pictured in 1910 with first assistant keeper Al Scott, his wife, Florence Jardine Scott, and their children, Martha Scott, Alton Scott, and Floyd Scott, on the porch. (Courtesy Point Cabrillo Lightkeepers Association [PCLK] and Susan Pritchard O'Hara.)

IMAGES
of America

POINT CABRILLO
LIGHT STATION

Bruce Rogerson and the
Point Cabrillo Lightkeepers Association

ARCADIA
PUBLISHING

Published by Arcadia Publishing
Charleston SC, Chicago IL, Portsmouth NH, San Francisco CA

Printed in the United States of America

Library of Congress Catalog Card Number: 2008928308

For all general information contact Arcadia Publishing at:
Telephone 843-853-2070
Fax 843-853-0044
E-mail sales@arcadiapublishing.com
For customer service and orders:
Toll-Free 1-888-313-2665

Visit us on the Internet at www.arcadiapublishing.com

*To the light keepers of the U.S. Lighthouse Service
and U.S. Coast Guard and their families, who served at the
Point Cabrillo Light Station, 1909–1972.
Semper Paratus*

CONTENTS

ACKNOWLEDGMENTS

The Point Cabrillo Light Station will celebrate 100 years of service to the maritime communities on the north coast of California on June 10, 2009. In recognition of the centennial, the board of the Point Cabrillo Lightkeepers Association asked me to take on this project with Arcadia Publishing, Inc., to put together and publish an illustrated history of this historic site. I would like to thank Jim Kimbrell, executive director, and my fellow board members at Point Cabrillo for their support, and to Ray Duff who helped me access the light station's archives and collection of photographs.

This book would not have been possible without the cooperation of the following organizations: the Kelley House Museum in Mendocino, the Mendocino Coast Historical Society, the San Francisco Maritime National Historic Park, the Fort Ross Interpretive Association, and the U. S. Lighthouse Society. I was also fortunate to receive permission to use illustrations from author Dr. Thomas N. Layton's books about the 19th-century clipper brig *Frolic*, which were used to tell the *Frolic*'s story in chapter one. I am also indebted to several people connected to Point Cabrillo through the keepers and their families who served at Point Cabrillo between 1909 and 1972. These include: Flora Gordon of Mendocino, Nancy Baker of Oakland, Geene Miller in Chico, Buck and Frances Taylor in North Carolina, Vern Gillispie from Fresno, and the descendents of Lena Baumgartner, the Moores, and the Smiths. I also would like to thank Carol O'Neil for her assistance in accessing photographs of the late Harry Miller as a small boy. I am also indebted to Nan Walter, a volunteer at Point Cabrillo and an expert graphic artist, who worked on improving some of the poorer historic photographs and designed the maps. Unless otherwise specified, all images are courtesy of the author's collection.

While not directly related to the creation of this book, it is appropriate to acknowledge the contributions of the volunteers and staff members at the Point Cabrillo Light Station during the past 15 years. Without the thousands of hours of volunteer time, this light station—described as one of the most historically complete on the West Coast of the United States—would not be what it is today. Volunteers at Point Cabrillo have repaired buildings, wielded paint brushes, planted gardens, cut grass, restored the priceless fabric of the beautiful Fresnel lens, staffed the retail operation in the lighthouse, led walks, developed a beautiful aquarium exhibit, and greeted visitors 365 days a year. Without this loyal band of volunteers, events like the annual whale festivals in March would be impossible, lens tours would not happen, much needed educational programs for local schools would not be funded, and, most importantly at this time, the much anticipated centennial would go uncelebrated. To them I say, on behalf of the board of the Point Cabrillo Light Keepers Association, "Well done, thank you!"

INTRODUCTION

In terms of age, the Point Cabrillo Light Station is a mere youngster, having first been lit in June 1909. However, the location of the lighthouse, a 50-foot bluff located two miles north of Mendocino on the rugged coast of Northern California, is of great historical significance. Less than half a mile to the north lies Frolic Cove, the site of one of the most important shipwrecks on the Pacific Coast. Two miles to the south, at the mouth of Big River, is the site of the first lumber mill on the Mendocino Coast. Point Cabrillo is named after Juan Rodriguez Cabrillo, the earliest European navigator and explorer to visit the Pacific Coast of California. One of his lieutenants is reported to have sailed this coast in 1542 and may have named Cape Mendocino after the Spanish governor of New Spain (Mexico), Antonio de Mendoza.

The coastal prairie grasslands around what is now Point Cabrillo were the summer gathering grounds for the local Mitom Pomo peoples for thousands of years. With the arrival of the European settlers in the 1850s, the prairie grasslands passed into European ownership and provided pasture for cattle and sheep. The great redwood and Douglas fir forests were cut down to supply the needs of the burgeoning California economy in the wake of the California Gold Rush. Lumber mills sprang up in every little cove and inlet along the rugged Mendocino Coast, served by a network of skid roads in the early days and railroads reaching even deeper into the coastal woodlands. To move the sawn lumber to the markets in California and farther away, the only viable means of transportation in the early days was by sea, south along the long, exposed coast of Northern California. Small, hardy, two-mast lumber sailing schooners were developed, based on the East Coast fishing schooners, and came to be called dog-hole schooners for their ability to maneuver in the tight quarters of the coves on the coast, known to locals as "dogholes." Later in the 19th century, steam power was added to the craft, and they became know as steam lumber schooners.

During the second half of the 19th century, the U.S. Lighthouse Service responded to the increase in maritime trade along the north coast of California by building a network of lighthouses from San Francisco Bay north to the Oregon border. The gap between the Point Arena lighthouse and the Cape Mendocino Light was not filled until the early years of the 20th century, with the construction of the light station at Point Cabrillo. The opening of the light station in June 1909 was a cause for celebration in the locality, and the light keepers with their families quickly became part of the communities of Pine Grove, Mendocino, Caspar, and Fort Bragg.

The civilian light keepers at Point Cabrillo kept the light lit and the great air horns of the fog signal apparatus operational as important aids to navigation for the lumber schooners and other vessels trading along the coast through the storms, endless days of fog, a world war, and the Great Depression. Then came more change, with the lighthouse service being absorbed into the U.S. Coast Guard in 1939, the war years of World War II, the automation of the light, and the decommissioning of the station in the 1970s.

The final chapters of the history of the light station are still being written, such as the acquisition of the light station by the California State Coastal Conservancy (CSCC), the restoration of the historic Fresnel lens and the light station buildings, and the wonderful recounting of the *Frolic* story by Dr. Thomas N. Layton in his two books. This illustrated history of Point Cabrillo endeavors to tell the story in 128 short pages in time for the light station centennial in June 2009.

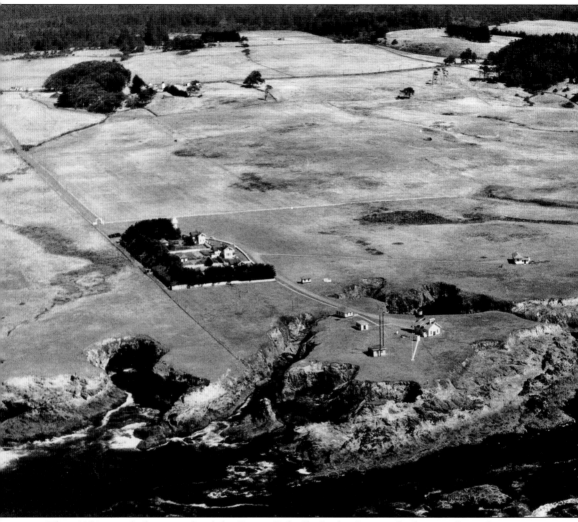

This 1950 aerial photograph of the Point Cabrillo Light Station looks east from the ocean. The image includes almost all of the original buildings from 1909. In the right foreground, the lighthouse and fog signal building can be seen sitting on the bluff, connected by a narrow neck of land to the rest of the station, with two deep coves to the north and south. To the left and toward the ocean sits the radio building and tall antenna towers constructed during World War II. Behind these are the oil house and smithy. Out to the far right is the barn, and on the road leading up from the lighthouse, the early pump house can be seen on the right. The three keepers' houses are on the left of the road, up from the lighthouse, protected on three sides by a windrow of trees. The water tower for the station, now painted white, can be seen faintly behind the third house. The lighthouse road leads east up the hill to the county road (in the middle background) and the community of Pine Grove. Visitors often ask what is the difference between a lighthouse and a light station. A lighthouse is the single structure on which the light is mounted. The light station is the assembly of support structures and the lighthouse itself, as pictured here. (Courtesy USCG.)

One

THE EARLY YEARS

The coast of Mendocino County lies on the western periphery of the North American Plate. Four miles off the present-day coast is the San Andreas Fault, the source of the great San Francisco earthquake of 1906. Twelve-thousand years ago, as the last major Ice Age declined, the ocean level was much lower than today, and the coastline was several miles west of present-day Point Cabrillo. The coastal features present at Point Cabrillo are the product of the major tectonic forces over millions of years as the Pacific Plate clashed with the North American Plate, producing several levels of marine terraces, with their sandy deposits, twisted and gnarled masses of gray wacky rocks, and loamy soils.

The earliest evidence of human occupation in Mendocino has been dated to 11,000 years ago. For thousands of years, the grassy coastal bluffs were home to the Native American tribes, including the Mitom Pomo and other coastal Pomo, who gathered the bounties of the coastal prairie and the ocean waters.

The Pomo might have witnessed the early European navigators on the coast starting in 1542, when the two vessels of Juan Rodriguez Cabrillo first sailed north from San Diego. In the late years of the 16th century, they might have observed the billowing sails of the Spanish treasure galleons from Manila heading south to Acapulco. More were to follow in exploration of the Pacific Northwest, including Capt. George Vancouver and the ships of the Russian-American Company on their voyages from Alaska to the settlement at Fort Ross to the south on the Sonoma coast.

The ancient culture and way of life of the Pomo people was largely protected by their remoteness from the older European Spanish settlements elsewhere in California. This changed dramatically in the 1850s following the wreck of the *Frolic* and the ensuing rush of European settlers to exploit the vast timber resources of the coast. The Pomo were forced off their ancestral lands onto reservations and suffered harsh treatment at the hands of the settlers, disease, and poor living conditions during the remaining years of the 19th century.

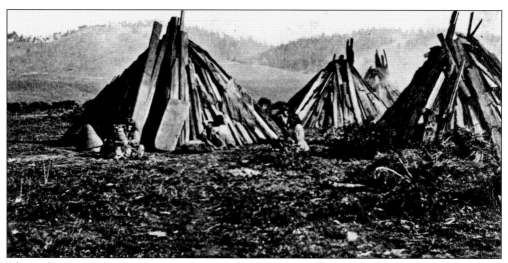

The indigenous Mitom Pomo people used the grassy, windswept headlands on the coast as a summer gathering site, moving down from their winter villages in the coastal hills and forest around present-day Willits in large family groups in the late spring and early summer each year. The upper photograph shows the typical dwellings of the Pomo, which were made from large slabs of redwood. The Pomo people fished, hunted for deer, and gathered salt, seaweed, and shellfish, including abalone, mussels, chiton, and barnacles. The women also gathered grasses, plant leaves, and fine stems from local shrubs as materials for their beautiful and utilitarian baskets for which the Pomo were noted. In the photograph below, two Pomo are working on basket weaving beside their huts. (Both, courtesy Kelley House Museum.)

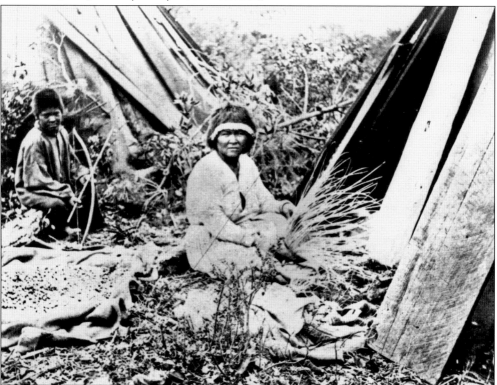

The Pomo lived in smaller family groups with many generations rather than in the large tribal groups typical of the plains Indians elsewhere in the West. The young children were commonly carried on their mother's backs in specially made cradles using locally available materials. In this photograph, the young Pomo infant is lying in its cradle, being watched over by its mother or perhaps grandmother. (Courtesy Kelley House Museum.)

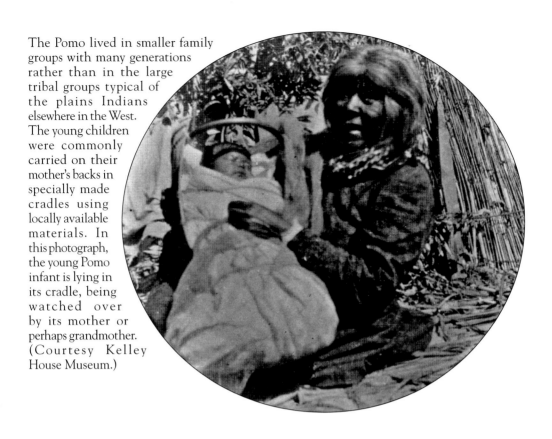

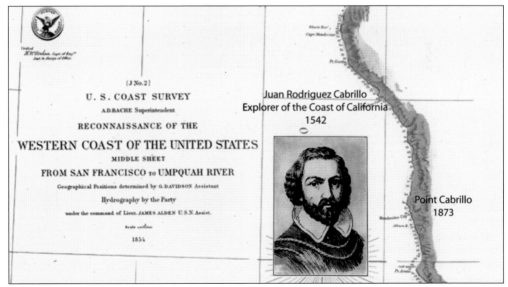

Point Cabrillo is named for Juan Rodriguez Cabrillo, the earliest European navigator and explorer to visit the Pacific Coast of California in 1842. His deputy, a Lieutenant Ferello, might have named Cape Mendocino after the Spanish governor of New Spain (Mexico), Antonio de Mendoza. The name was given to the point in 1870 by the U.S. Coast Survey.

From 1565 to 1815, the great Spanish Manila galleons, returning from Manila in the Philippines to Acapulco, Mexico, with their rich cargoes, followed the westerly winds across the north Pacific until they sighted Cape Mendocino, a turning point for them to head south along the coast of Northern California to Mexico.

During his epic three-year circumnavigation of the world from 1577 to 1579, Sir Francis Drake explored the waters off Northern California in his vessel, the *Golden Hind*. He might have sailed as far north as Vancouver Island, according to some accounts. If true, then the *Golden Hind* might have coasted the waters off Point Cabrillo in those early years. (Painting by B. Tabia, courtesy Dolphin Isle Marina.)

In 1603, Sebastian Vizcaino, after sighting Cape Mendocino on January 21, 1603, coasted south in his ship, missing the entrance to San Francisco Bay but landing in what was to be named Monterey, which would provide a safe anchorage for the galleons during the next two centuries. Cape Vizcaino, located 20 miles north of Point Cabrillo, is named for the early Spanish navigator. (Courtesy California State Parks.)

On April 18, 1792, George Vancouver's two ships, the *Discovery* and the *Chatham*, made landfall within sight of present-day Point Cabrillo to begin their great voyage of exploration and mapmaking on the northwest coast of the Americas. During the next two years, Vancouver explored and charted the coast from California to Alaska, naming many features along the coast. On his charts he still referred to California and the Oregon territory as New Albion, the name first used by Sir Francis Drake 200 years earlier.

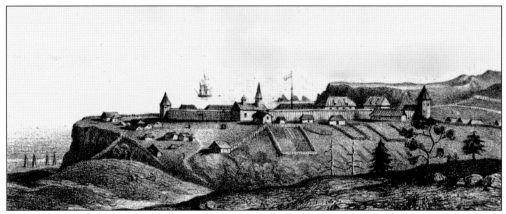

Pictured here is a drawing of the Russian Fort Ross from 1828 by A. B. Duhaut-Cilly. In 1812, the Russian-American Company founded the settlement of Fort Ross 50 miles south of Point Cabrillo. This community lasted from 1812 to 1841, and vessels trading with Fort Ross would have sailed close to modern-day Point Cabrillo. (Courtesy Fort Ross Interpretive Association and California State Parks.)

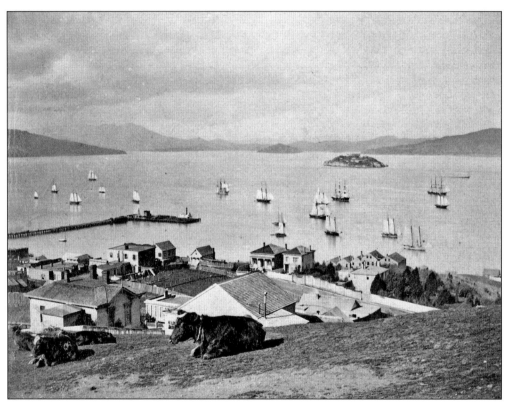

In 1848, gold was discovered at Sutter's Mill, and the great Gold Rush ensued. Within months, the tiny community of Yerba Buena on San Francisco Bay blossomed into the town of San Francisco. This 1851 photograph shows Meiggs Wharf, San Francisco, where the *Frolic* was bound on her ill-fated voyage in 1850. (Photograph by Edwin Muybridge, courtesy San Francisco Maritime National Historical Park, from the Bancroft Library Collection.)

Half a mile north of the Point Cabrillo Light Station in a small cove, lie the remains of the sleek, fast clipper brig *Frolic*, a fine example of 19th-century American sailing ship technology at its nadir. The *Frolic* was built in 1844 at the yard of Gardner Brothers in Baltimore, Maryland, for the New England shipping partners of Augustine Heard and Company. Constructed of pine and oak, she was 97 feet long, 24 feet in beam, and drew 10 feet amidships. The *Frolic* was armed with two cannon, swivel-mounted bluderbusses, and other small arms to ward off pirates, who were common in the narrow straits of the East Indies. The *Frolic*'s original crew was almost entirely American, but in her later voyages, many of her crew were Chinese, Iascars from the west coast of India, or Malaymen from the East Indies. From 1845 to 1849, under the command of Capt. Edward Faucon, the *Frolic* successfully traded between Bombay and the west coast of India to south China ports, carrying cakes of opium in wooden chests, which at that time was a semi-legal trade sanctioned by the British Raj. A catastrophic dismasting in a typhoon off Hong Kong in the fall of 1849, the advent of steam-powered vessels, and a decline in available opium cargoes, forced her owner and agents to look elsewhere for suitable cargo. (Illustration by S. F. Manning, courtesy Dr. Thomas N. Layton.)

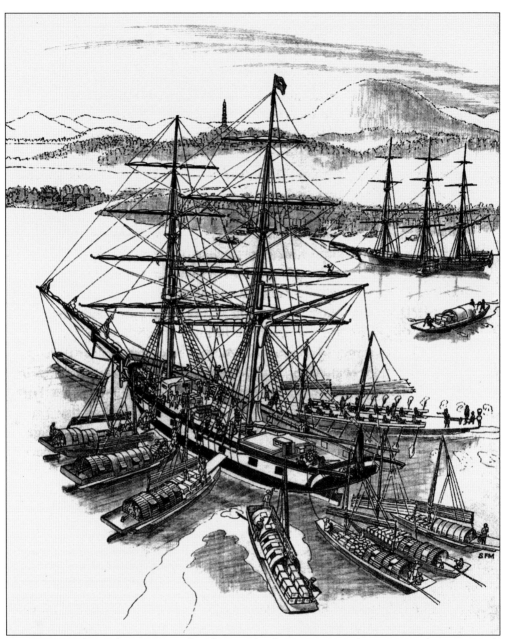

In May 1850, the *Frolic* is seen in this drawing loading cargo at Whampoa Anchorage, South China. News of the gold discoveries in California in 1848 was well known in China by then. Captain Faucon and the owner's agent decided to purchase a cargo of Chinese merchandise to be loaded on the *Frolic* and carried across the Pacific Ocean to San Francisco, where such cargo would attract a good price in the newly prosperous and expanding metropolis by the bay. Included in this valuable cargo were bales of silk, cheap porcelain, furniture, a prefabricated house, and 6,009 bottles of Edinburgh ale. The *Frolic* sailed on June 10, 1850, on her ill-fated voyage to San Francisco following the ancient route of the great Manila galleons, taking advantage of the prevailing "los vendavales," as the Spanish sailors called them, the strong southwesterly winds across the north Pacific Ocean. (Illustration by S. F. Manning, courtesy Dr. Thomas N. Layton.)

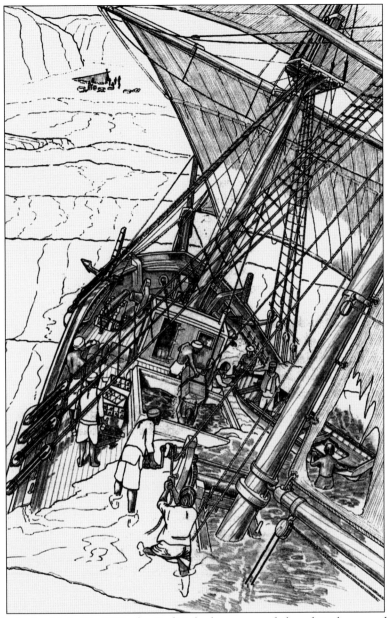

In the early dusk of July 25, 1850, the *Frolic*'s lookout spotted the white loom and heard the roar of the breaking surf ahead. Despite valiant efforts by the captain and crew to ware the ship around and beat off the lee coast, the stern of the *Frolic* was flung against a rock by a breaking swell, smashing off her rudder and cracking several planks, flooding the cargo hold and crew spaces. As the *Frolic* started to founder, her master, officers, and some of her lascar and Chinese crew took to the ship's boats and eventually reached Bodega Bay to the south and San Francisco. Other members of the crew stayed with the ship to recover supplies they would need to survive on shore. The water-logged hull of the *Frolic* eventually, with some help from the remaining crew working the anchors and windlasses, lodged in what is known today as Frolic Cove, just north of Point Cabrillo. This illustration shows the ship's bosun and crewmembers saving supplies from the vessel. (Illustration by S. F. Manning, courtesy Dr. Thomas N. Layton.)

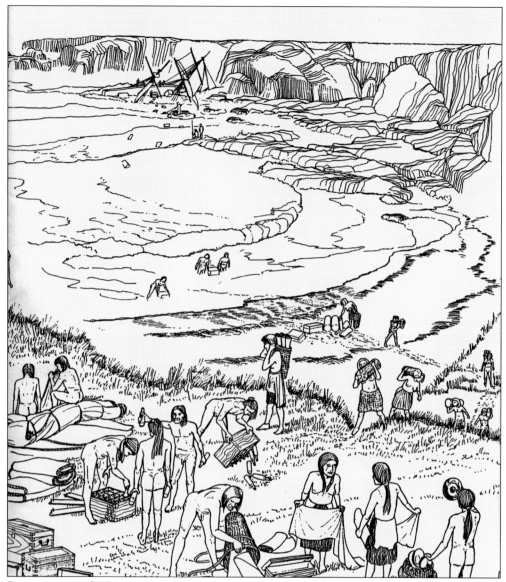

Being summer, the Mitom Pomo were living on the coast and witnessed the wreck of the *Frolic*, some of her crew leaving the ship, and the remainder salvaging supplies from the ship's stores and cargo hold. As the ship foundered and the crew left, the Pomo men went out to the wreck to collect the bounty afforded them by this maritime casualty on their doorstep, and the women picked up items of cargo that floated free and came ashore along the cove. Early recollections and accounts by European settlers tell of Indian women trading bolts of Chinese silks and of large Chinese vases being seen in early adobes inland in Mendocino County. The many middens on the site also contain evidence, in the way of broken pottery shards and pieces of bottle glass, of the Pomo's interaction with the wreck of the *Frolic* in 1850. By the time Jerome Ford and his team of hopeful salvors arrived in the following spring, the winter storms and the Pomo had accounted for most of the cargo from the *Frolic*. (Illustration by S. F. Manning, courtesy Dr. Thomas N. Layton.)

Two

TIMBER IS KING

The year following the wreck of the clipper brig *Frolic* on the remote north coast of California, Harry Meiggs, the owner of the dock where the *Frolic* was bound, sent Jerome Ford to investigate the wreck. All the valuable Chinese cargo had already been removed or had been destroyed by the winter storms. Instead Ford discovered the vast stands of redwoods and Douglas fir, and the small coves, or "dogholes," along the shore that might be able to harbor a ship large enough to transport lumber, which was in demand for the expansion of San Francisco in the midst of the Gold Rush fervor. A year later, in July 1852, the first sawmill was shipped around Cape Horn from the East Coast, and after being transshipped in San Francisco, landed on the beach at Big River. More mills followed until every inlet and creek mouth had a mill churning out rough sawn redwood and Douglas fir planks for shipment to the south and the growing metropolis of San Francisco and other California ports.

For almost 100 years, timber was king and provided the cargo, lumber, ties, shingles, pilings, and more produced by the sawmills dotting the Mendocino coast from Shelter Cove and Bear Harbor in the north to Gualala and Stewart's Point to the south. The ocean provided the highway to the markets in America and abroad for the redwood lumber products of the county. The schooners, both sail and steam powered, provided the means of delivery, in summer and winter, through any kind of wind and weather the Pacific Ocean could throw at their hardy and skilled crews. The trade lasted almost a century beginning in 1853 and ending in the Depression years of the 1930s as the rail car and the road truck replaced the ubiquitous cargo vessels of the coast.

The sturdy schooners also carried passengers up and down the coast for many years, offering speedier and, most of time, more comfortable journeys than could be had by stagecoach over the poor county roads before the advent of rail travel on the north coast of California in the 1900s.

This is a photograph of Jerome B. Ford, taken in his later years in Oakland. Ford led a small party north from Bodega Bay in the late spring of 1851 in search of the wreck of the *Frolic* in hopes of finding valuable cargo to salvage. However, Ford found a far greater prize for the taking—the great groves of virgin old growth redwoods and Douglas fir. (Courtesy Kelley House Museum.)

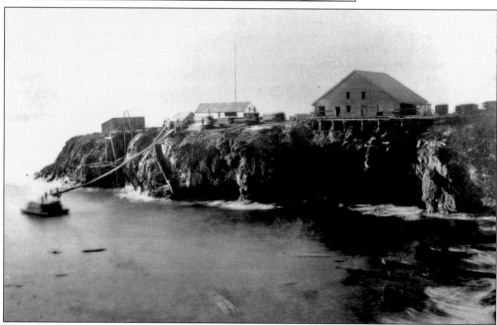

This is a 1863 photograph of the first lumber mill on the bluffs southwest of the village in Mendocino. Following Jerome Ford's visit in the summer of 1851, Henry Meiggs and his partners ordered the mill machinery from the East Coast. It was shipped around Cape Horn in 1852 to San Francisco and arrived in Big River Bay on July 19, 1852. (Courtesy Kelley House Museum.)

The great redwood trees, many more than 1,000 years old and standing 250 feet or more in height and with a diameter of up to 20 feet, presented a huge challenge to the early lumberjacks and loggers on the coast of Mendocino. To fell the huge trees required several days' hard toil for a team of choppers, sawyers, and fellers working with hand axes, long two-handled saws, and wedges. (Courtesy Kelley House Museum.)

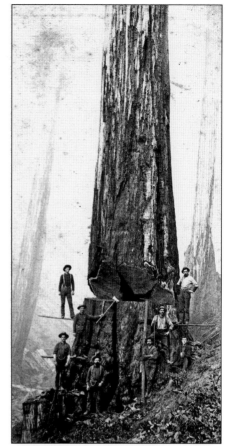

The fellers stood on boards driven into the tree bark to allow them to work at the right height. An under cut was made to direct the fall of the huge tree and then the final cut was made to bring the tree down, generally on a prepared mass of under brush to soften the landing and prevent the huge trunk from shattering. (Courtesy Kelley House Museum.)

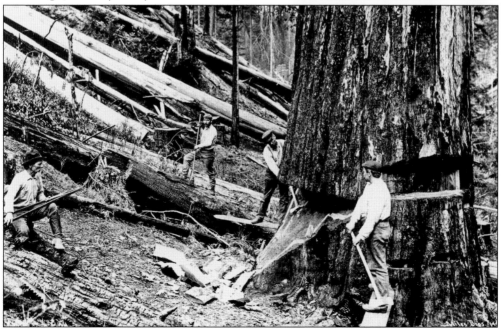

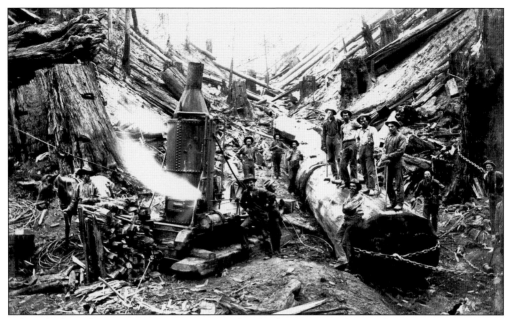

After the huge logs were cut into sections, they had to be moved from the landing to the river or to the closest logging railhead. This was done in the early days with teams of oxen and, later in the 19th century, using the portable steam winches mounted on a wooded sled known as the Dolbeer donkey engine, such as the one in this photograph. (Courtesy Kelley House Museum.)

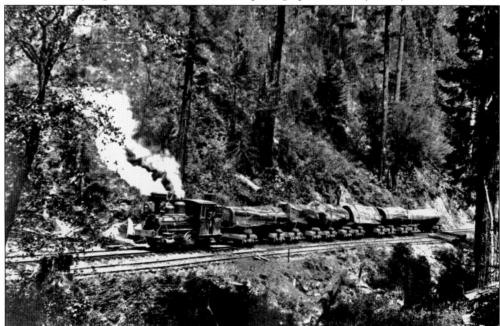

This shows the steam locomotive *Daisy* of the Caspar Lumber Company hauling flat cars loaded with large redwood log sections. As the logging moved away from the coast and rivers, railroads were used to get the logs to the mills. The locomotive *Daisy* was saved from the scrap yard and was restored by volunteers. It can be seen today in the Depot Mall in Fort Bragg. (Courtesy Kelley House Museum.)

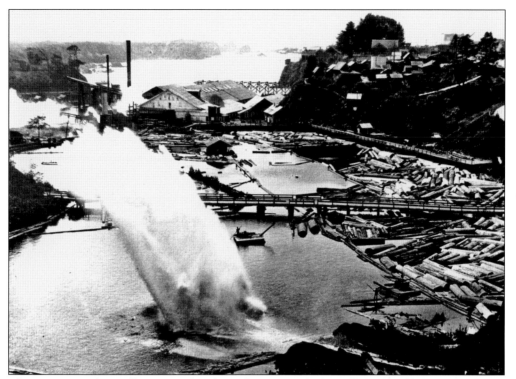

The Caspar Lumber Mill is pictured in the early 1900s with the mill pond in the foreground, into which a large log has just been dropped after having been unloaded from one of the logging rail flat cars above the pond. The first mill at Caspar opened in 1867 and was located less than one mile north of Point Cabrillo. (Courtesy Kelley House Museum.)

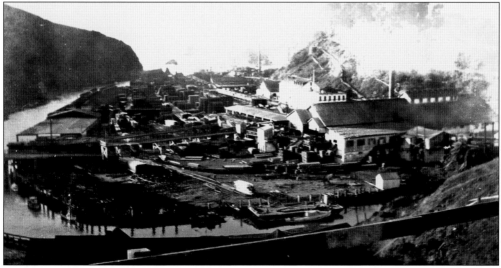

The Albion Mill at the mouth of the Albion River south of Mendocino Village is shown in its heyday in the late 1890s. The Albion Mill used extensive logging railroads running inland from the mill into the hinterland of the Albion River. At one point, plans were made to connect Albion to the Russian River Valley by rail to the Pacific Northwest Railroad system. (Courtesy Kelley House Museum.)

The Little River Mill, located two miles south of Mendocino, operated from 1872 to 1893. The mill had a 330-foot wharf with two chutes and was a port of call for the coastal passenger ships. In addition to the mill and adjacent township, Little River also had a productive shipbuilding yard operated by Tom Peterson, who constructed sailing schooners and fishing boats. (Courtesy Kelley House Museum.)

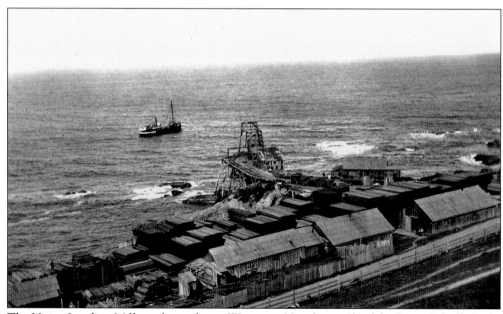

The Union Landing Mill was located near Westport, 20 miles north of the Point Cabrillo Light Station. The mill operated from 1900 to about 1925. The site of this mill is now the Westport Union Landing State Park. A steam lumber schooner is waiting to load a cargo of lumber under the mill wire chute. (Courtesy Kelley House Museum.)

In the early years, the mainstay of the coastal lumber trade was the two-masted sailing schooner. They were less than 100 feet in overall length with a broad beam and a shallow draft to enable them to lie close to shore to load their lumber cargoes. This photograph shows the schooner *Gualala* under its typical fore-and-aft sail arrangement with a full load of lumber. (Courtesy Kelley House Museum.)

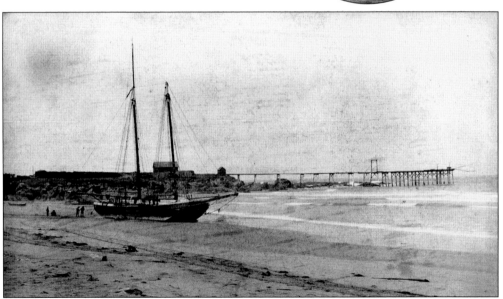

The hay scows of the San Francisco Bay sometimes ventured north to pick up a cargo of lumber. With their square bows and shallow draft, they did not sail well into the prevailing winds, which made their trip north long. Here the scow schooner *Sacramento* is seen on the beach at Cleone, waiting to load at the Cleone Wharf, c. 1889. (Courtesy San Francisco Maritime National Historical Park.)

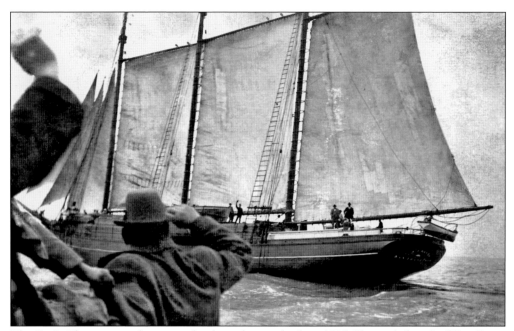

The C. A. *Thayer* was a three-mast lumber schooner built in 1885. She traded in the West Coast lumber trade until 1912, when she joined the summer fishing fleets in Alaskan waters. In 1957, she was preserved from the breakers yard by the State of California. On her voyage from Puget Sound to San Francisco in 1957, she was saved from running ashore on the Mendocino Coast by the lighthouse at Point Cabrillo. (Courtesy San Francisco Maritime National Historical Park.)

The sailing schooner *Bobolink* is shown on San Francisco Bay at the end of a voyage down the coast from a mill on the redwood coast. The *Bobolink* was built in 1868 in Oakland for A. H. Simpson and was 104-feet long with a 29-foot beam and drew just under 9 feet. (Courtesy Kelley House Museum.)

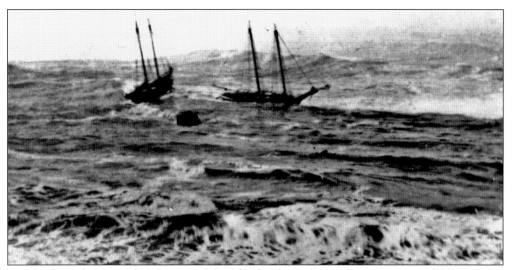

Two lumber schooners, the *Electra* and the *Alfred*, ride out big swells at moorings off Mendocino. The Mendocino coast was considered a dangerous lee shore because of the prevailing westerly and northwesterly winds. If heavy winds were expected, schooner captains would take their vessels off shore and ride out the storm in open water before returning to the loading port to complete their cargo load. (Courtesy Kelley House Museum.)

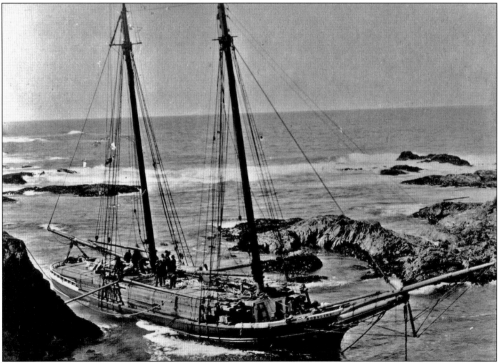

In 1898, the schooner *Bobolink* was wrecked at Kent Point at the south entrance to Mendocino Bay while leaving with a load of lumber. This was typical of the many wrecks of sailing schooners during the later years of the 19th century. One crewmember was drowned in the incident. The ship was owned by Jerome B. Ford of the Mendocino Lumber Company. (Courtesy Kelley House Museum.)

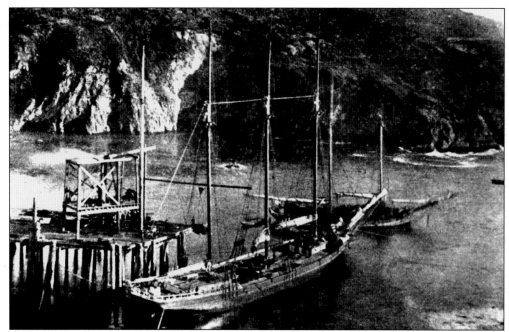

The mill at Albion River offered one of the more sheltered anchorage's on the coast with a pier that the schooners could tie up to while loading their lumber cargoes. Such facilities were rare on the coast and were found only at Fort Bragg Harbor in later years at the Union Lumber Company and at Arena Cove. The Albion Mill operated from 1891 to 1928. (Courtesy Kelley House Museum.)

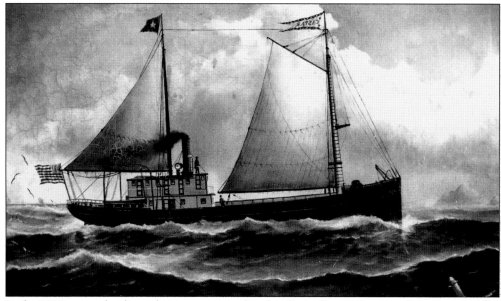

In the 1880s, several sailing schooners were outfitted with small steam engines driving a propeller. This enabled the vessels to maneuver in windless conditions into and out off the doghole ports and to make headway against the contrary winds often found on the coast. Owned by the Caspar Lumber Company, the *Caspar* was an example of an early steam schooner, which still carried significant sails. (Courtesy Kelley House Museum.)

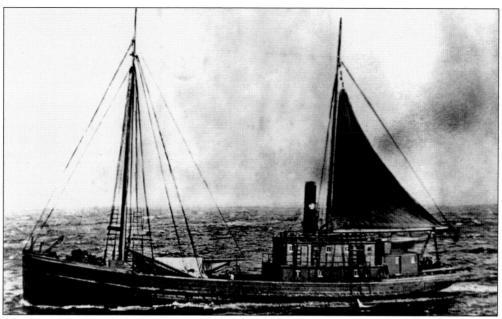

The first truly purpose-built steam schooner was laid down for the Robert Dollar Company in 1888 to haul lumber from the Usal Mill, north of Fort Bragg, which was owned by Robert Dollar. The new vessel was called the *Newsboy* and was the first steamship owned by Dollar, who went on to become a major shipping magnate in the early years of the 20th century. (Courtesy Kelley House Museum.)

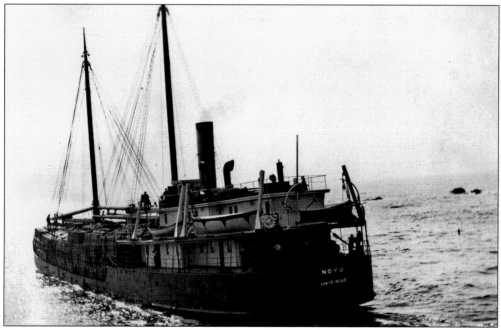

The Union Lumber Company in Fort Bragg operated the largest lumber mill on the coast from 1891 until the mid-20th century. Its steam schooners carried lumber from the Fort Bragg mill to ports as far south as Mexico. The vessel, named *Noyo*—the last of the fleet—is seen leaving Fort Bragg Harbor in the 1920s. (Courtesy Kelley House Museum.)

The steam schooner *Brunswick* is pictured at the Fort Bragg wharf loading lumber. Note the several heavy mooring lines, indicating that rough weather was expected. The Fort Bragg wharf, in what is also sometimes known as Soldier Harbor, was an exposed harbor with a narrow approach channel with dangerous reefs on either side, requiring careful boat handling by the master and crew. (Courtesy Kelley House Museum.)

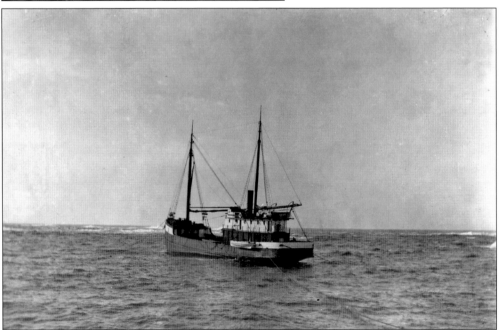

Another vessel of the Union Lumber Company fleet, the *National City* is lying off Fort Bragg Harbor waiting to load cargo. The *National City* was a popular vessel with local travelers and operated a regular passenger service for many years in the 1900s with scheduled stops at Mendocino City and Point Arena on her way to San Francisco. (Courtesy Kelley House Museum.)

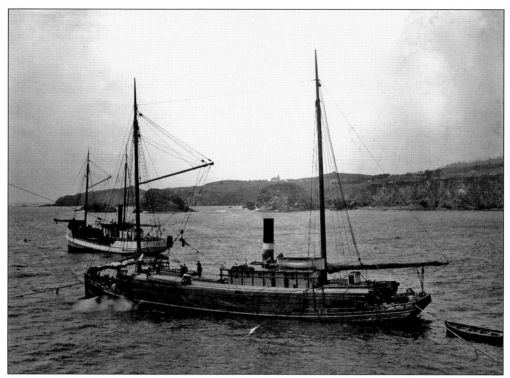

Pictured are two steam lumber schooners loading cargoes under the wire at Cuffey's Cove, just north of Elk. The nearer of the lumber schooners, the *Alcatraz*, has just received a sling load of lumber on deck, and the crew is manhandling the planks into stowage on her deck. The second steamer is the *Point Arena*. (Courtesy Kelley House Museum.)

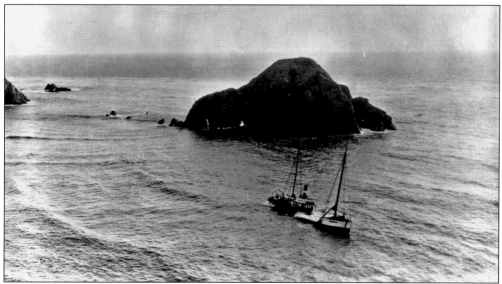

Many of the lumber schooners, both sailing and steam powered, came to a sad end, wrecked along the treacherous coast of Northern California. This photograph shows the *Point Arena* aground and listing, with the swell washing over her main deck in Greenwood Bay just south of Elk. Shortly afterward, she was declared a total loss and was abandoned. (Courtesy Kelley House Museum.)

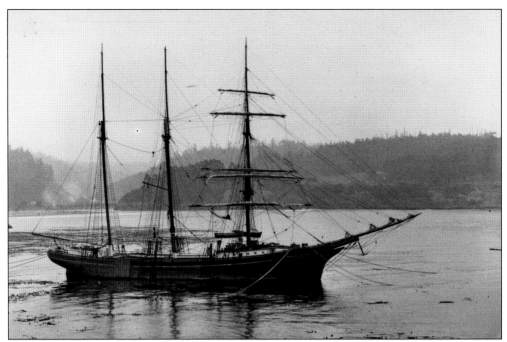

Larger cargo sailing vessels were common visitors to the bigger doghole ports of the redwood coast. Here the barkentine-rigged sailing ship *J. C. Griffin* is lying in Mendocino Bay awaiting her turn under the loading wire to take on a cargo of redwood lumber, possibly for Mexico or Hawaii or even Australia. (Courtesy Kelley House Museum,)

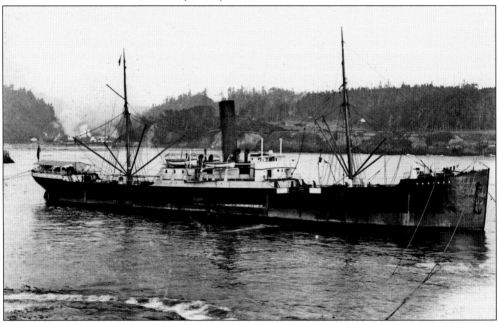

The British ocean-going steamer *Cacique* is moored in Mendocino Bay, awaiting a cargo of railroad ties for South America in 1912. She is held in place with long mooring lines attached to rings on eyebolts driven into rocks on the shore and to large mooring buoys anchored in the bay. Evidence of these mooring bolts and rings can still be seen today. (Courtesy Kelley House Museum.)

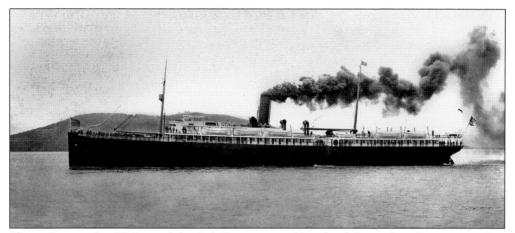

Shown here is the SS *Bear* of the San Francisco and Portland Steamship Company in San Francisco Bay around 1912. In the early years of the 20th century, fast steamships provided a regular passenger service on the Northwest Pacific coast from San Francisco to Eureka, Astoria, Portland, and Puget Sound ports. The *Bear* met a sad end on the beach off Cape Mendocino in fog in June 1916. (Courtesy San Francisco Maritime National Historical Park.)

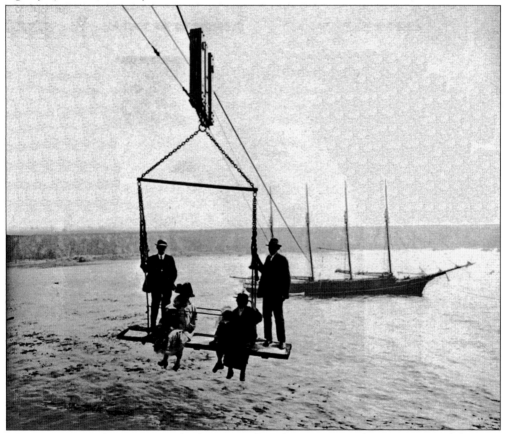

This photograph shows Capt. Schuyler Mitchell of the four-mast schooner *Irene* with his wife and fellow passengers riding the wire ashore at Noyo in 1916. (Courtesy Fort Bragg—Mendocino Coast Historical Society [FB-MCHS].)

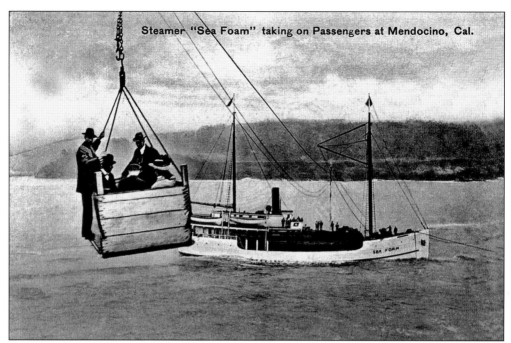

Here a group of passengers at Mendocino are riding a passenger gondola under the wire, down to the deck of the steam schooner *Sea Foam*, where they had to step out onto the top of the stowed lumber deck cargo before reaching the comparative safety of passenger accommodations aft on the vessel. (Courtesy PCLK and Susan Pritchard O'Hara.)

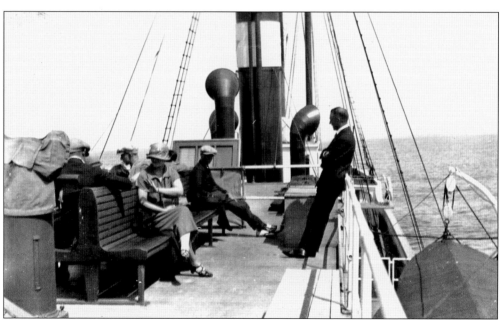

This photograph shows the passenger deck aft on one of the larger steam lumber schooners heading north from Fort Bragg to a port in Oregon. The image was taken in the 1920s based on the cut of the cloths of the passengers. The identities of the passengers and the vessel are not known. (Courtesy Kelley House Museum.)

Three

LIGHTING THE WAY

Following the establishment of U.S. jurisdiction over the Oregon territories and California in the 1840s, the U.S. Treasury and the Lighthouse Board moved quickly to establish lighthouses as critical aids to navigation along the Pacific Coast. The discovery of gold in the Sierra foothills in 1848 provided the impetus for a rapid increase in maritime activity along the coast of California. Moving north from San Francisco Bay, lighthouses were constructed on Alcatraz Island in the bay in 1854, at Point Bonito at the entrance to the Golden Gate and San Francisco Bay in 1855, the Humboldt Bay light in 1856, and one at Crescent City also in 1856. Cape Mendocino was completed in 1868; Point Reyes, an important turning point for ships in western Marin County, in 1870, and Point Arena in southern Mendocino County, also in 1870.

To construct the first eight lighthouses on the West Coast, the treasury department pooled the monies voted by Congress for the projects and hired a single contractor to do the work. Gibbons and Kelly was awarded the contract, and the ship *Oriole* was dispatched, loaded with materials and workers in 1852. After finishing four lighthouses in the San Francisco Bay area and Monterey, the *Oriole* headed north to the Columbia River in the Oregon territory, where she ran aground on the treacherous shoals at the Columbia Bar. All the men aboard were rescued, but the materials for the four remaining lighthouses were lost, delaying construction for several years.

In addition to the lighthouses in the late 19th century, lifesaving stations were established by the U.S Lifesaving Service along the coast of Northern California. There were active lifeboat stations at Fort Point in San Francisco Bay, Point Reyes, Bolinas Bay, in Marin, Arena Cove south of Point Arena, and Humboldt Bay. These stations and their lifeboat men played a vital role in rescuing the crews of vessels in distress on the coast from 1871 to 1915, when the Life Saving Service was merged with the Revenue Cutter Service to form the foundation of the modern U.S. Coast Guard.

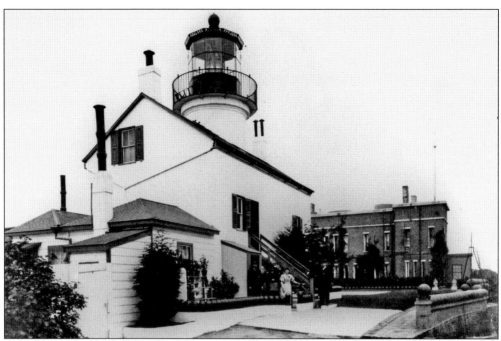

The first lighthouse on the Pacific Coast was the Alcatraz light, built in 1854 using a Cape Cod design already widely seen on the East Coast. The first lighthouse was constructed by Gibbons and Kelly, and displayed a third-order Fresnel lens for the first time on June 1, 1854. A manual fog bell was added in 1856, which greatly increased the workload of the keepers because of the frequency of fog in San Francisco Bay and the Golden Gate area. Shortly afterwards, a clockwork mechanism was added, which eased the workload of the keepers in foggy conditions. In 1909, the original lighthouse was demolished following damage in the 1906 earthquake to make way for a new, higher tower, visible over the ramparts of the Alcatraz prison buildings and sporting a new fourth-order Fresnel lens. (Both, courtesy U.S. Lighthouse Society.)

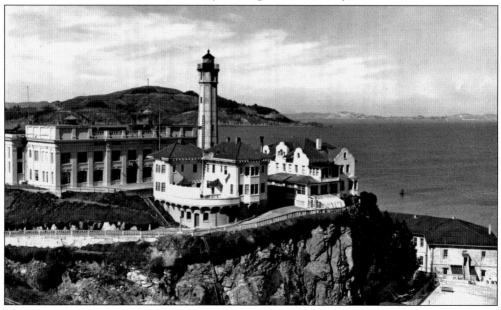

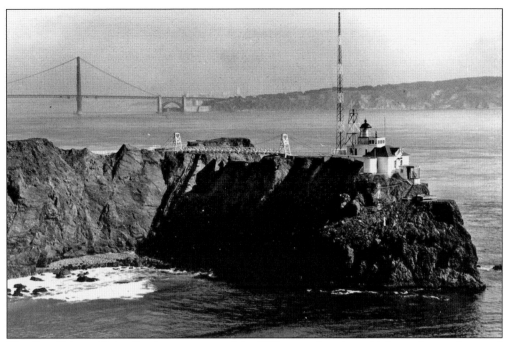

The first light at Point Bonita, constructed in 1855, was placed too high on the north portal at the entrance to the Golden Gate and was often obscured by fog. The light was rebuilt in 1877 at a lower elevation and is the building seen today at Point Bonita guiding ships into the famous Golden Gate with its fixed second-order Fresnel lens and fog signal. (Courtesy U.S. Lighthouse Society.)

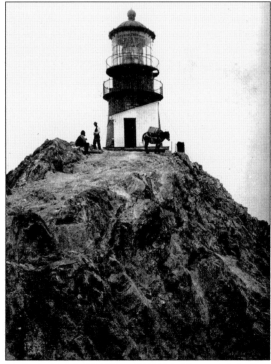

Work on the light on the southeast Farallones started in 1852, but it was not until 1855 that the new first-order lens was first lit on this remote and rugged group of islands 27 miles west of the Golden Gate. The original first-order lens from the East Farallon light is now on display in the San Francisco Maritime National Historical Park. (Courtesy U.S. Lighthouse Society.)

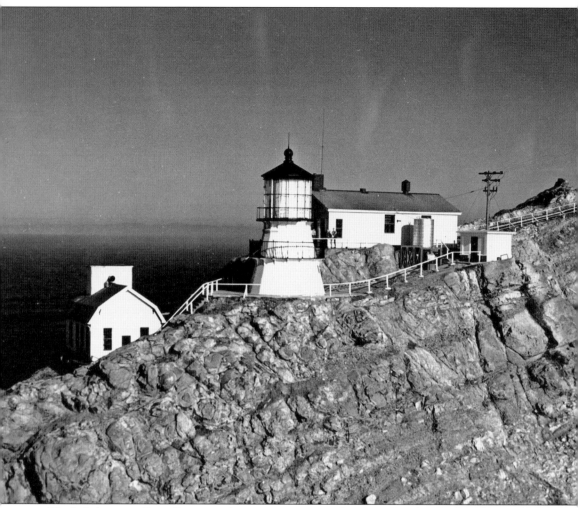

The lighthouse at Point Reyes stands on a prominent rocky point 18 miles north of the Farallon Islands and was major turning point for coastal vessels coming and going from the Mendocino coast and ports to the north. In 1579, it is believed that Sir Francis Drake careened his ship, the *Golden Hind*, in the shadow of Point Reyes on the beaches and below the white cliffs of the bay named after him. In 1595, the Manila galleon *San Agustin* of Sebastian Cermeno's expedition wrecked on the treacherous sands of Drakes Bay near today's lighthouse. The lighthouse was completed in 1870, and the beautiful first-order Fresnel lens, manufactured by Barbier and Fenestre of Paris, was first lit on December 1, 1870. The original lens is still on display at the Point Reyes Light Station. (Courtesy U.S. Lighthouse Society.)

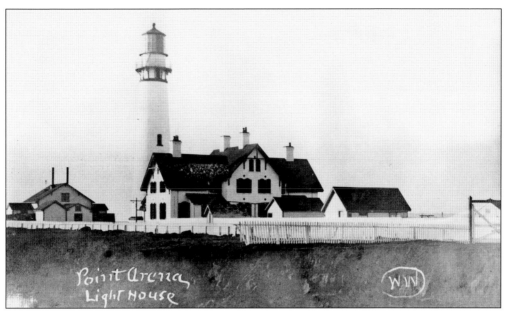

Point Arena lies 68 miles northwest of Point Reyes on a low point jutting westwards into the Pacific Ocean in southern Mendocino County. The lighthouse at Point Arena was built in 1870, and the first-order lens was lit on May 1, 1870. The original light tower and keepers' dwelling were severely damaged in the 1906 San Francisco earthquake because the San Andreas Fault runs close to the light station. A new concrete tower and three keepers' houses were constructed in 1907 and were opened in 1908. Today the light is an automated modern lens, but the unique double flash first-order Fresnel lens is still in the lantern room. It is scheduled to be restored and moved to a display in the original fog signal building at the foot of the light tower in the near future. (Both, courtesy Point Arena Lightkeepers, Inc.)

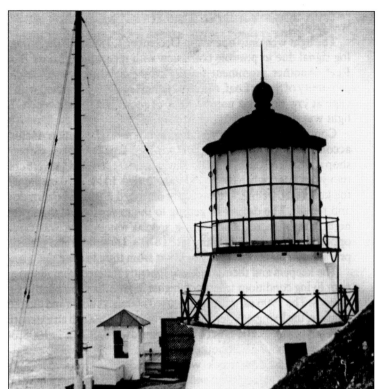

Cape Mendocino lies 185 miles north of San Francisco on a high and prominent headland that, for almost 250 years, was a major landfall for the Manila galleons of Spain. The U.S. Lighthouse Service identified this as a critical location for a major lighthouse and construction began in difficult conditions in 1867. The light was lit for the first time on December 1, 1868. (Courtesy U.S. Lighthouse Society.)

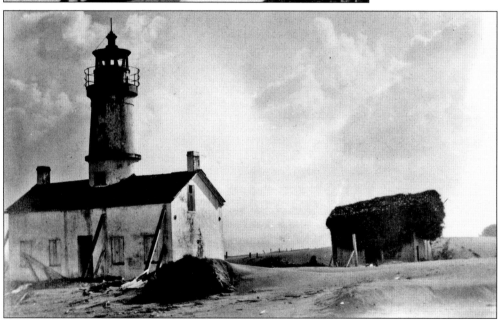

The Humboldt Bay light was built in 1856 at the entrance to the dangerous Humboldt Bay Bar and the port of Eureka, a major shipbuilding and lumber port on the north coast of California. In 1892, the lighthouse was abandoned, and a new light was established at Table Bluff, farther to the south of the bar entrance, with better visibility for ships approaching the shipping channel and breakwater. (Courtesy U.S. Lighthouse Society.)

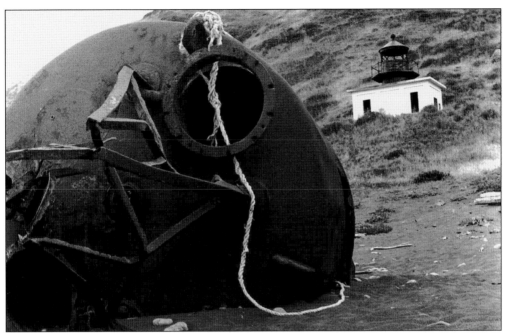

After construction of the light at Point Cabrillo in 1909, filling in the long, dark section of coast between the Point Arena light to the south and the Cape Mendocino light to the north, there still remained a significant unlit headland and dangerous waters at Punta Gorda, located 60 miles to the north. In 1912, the U.S. Lighthouse Service built a small, rectangular lighthouse at Punta Gorda, which in English means "massive point," with three light keepers' houses almost identical to those at Point Cabrillo and an oil house. Because of the difficulty in maintaining the light station in its remote location, the station was closed in 1951, and a light buoy was provided off shore. The keepers' dwellings were burned down in 1970 by the Bureau of Land Management to stop them from being used by squatters. Today only the light tower and the concrete oil house have survived. (Both, courtesy Nancy Barth.)

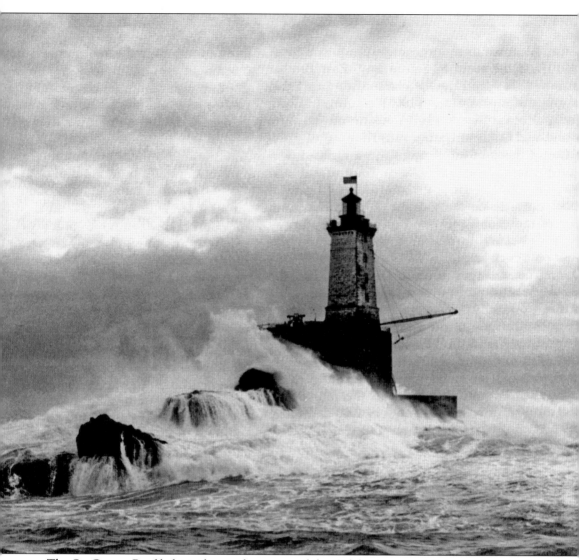

The St. George Reef light is the northernmost of the California coastal lights and marks the treacherous reefs off Point St. George, just north of Crescent City. Construction on this difficult site took 10 years and was completed in 1892. The lighthouse was built in response to the tragic wreck of the passenger steamer *Brother Jonathan* in 1865 on the reef. Two hundred-fifteen passengers did not survive. (Courtesy U.S. Coast Guard [USCG].)

Four

THE LIGHT STATION AT POINT CABRILLO

Although the U.S. Lighthouse Service surveyed Point Cabrillo as a possible lighthouse site as early as 1873, no further progress was made until 1904. Following a spate of disastrous shipwrecks and the resultant loss of life, petitions from local mill owners and ship owners became so numerous that at its session on October 3, 1904, the U.S. Lighthouse Service Board finally recommended the establishment of a light and fog signal station at or near Point Cabrillo. In late January 1905, Senate Bill No. 6648, an appropriation of $50,000 for the establishment of the station, was introduced and finally approved on June 20, 1906, which was within months of the disastrous San Francisco earthquake and fire.

Construction of the Point Cabrillo Light Station by the U.S. Lighthouse Service was commenced in August 1908. The original building contract was for $21,000, and the 30.5-acre property was purchased from local rancher David Gordon for $3,195. The contracted work was for the five main buildings of the station, the lighthouse/fog signal building, three keepers' dwellings, and the barn. At the same time, the U.S. Army Corps of Engineers constructed the additional improvements, including the access roads, sewers and water systems, a pump house, a blacksmith/carpenter's shop, and the three storage buildings at the rear of the houses.

By February 1909, all the structures were complete except for the storage buildings, and the first lightkeepers moved in. Wilhelm Baumgartner, the head keeper, with assistants George Bassett and Charles Below, helped finish the work. The corps and lightkeepers fenced the property, mounted the fog signal equipment, erected the iron-and-bronze lantern room on top of the light tower, and installed the third-order Fresnel lens.

The British-built Fresnel lens was first lit on June 10, 1909, by Wilhelm Baumgartner, the new head light keeper. The original light station included all of the structures seen today including the lighthouse, oil house, smithy, three keepers' houses, and the adjacent storage buildings, except the pump house and water tank behind the keepers' houses. A barn, a water tower, and the original pump house have since been removed.

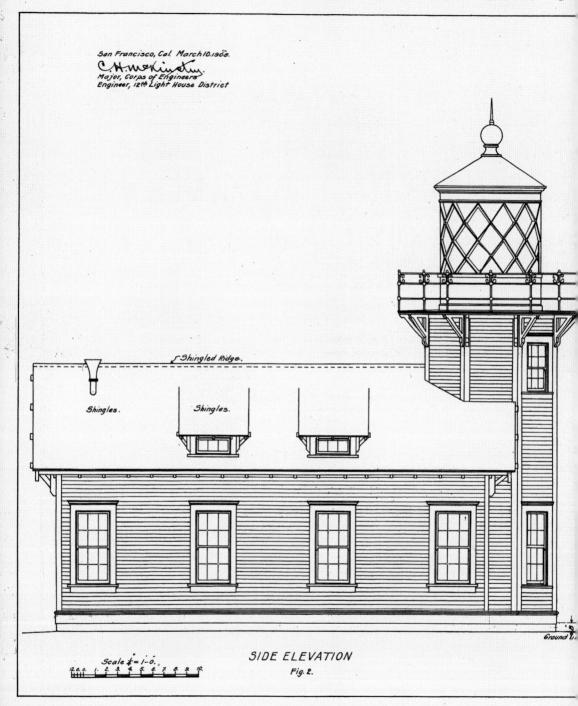

San Francisco, Cal. March 10. 1908.

C. H. McKinstry.
Major, Corps of Engineers
Engineer, 12th Light House District

Shingled Ridge.

Shingles. Shingles.

SIDE ELEVATION
Fig. 2.

Scale ¼ = 1'-0".

Ground

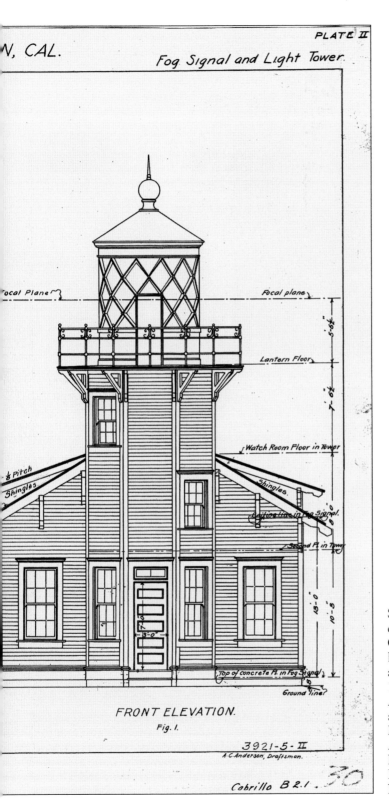

PLATE II

N, CAL.

Fog Signal and Light Tower.

Focal Plane

Focal plane

5'-6½"

Lantern Floor.

7'-0½"

Watch Room Floor in Tower

½ Pitch

Shingles

Shingles

Ceiling line in Fog Signal.

Second Fl in Tower

13'-0"

10'-8"

Top of concrete Fl. in Fog Signal

7'-0"

5'-0"

Ground line?

FRONT ELEVATION.

Fig. 1.

3921-5-II

A.G.Anderson, Draftsman.

Cabrillo B 2.1.

Shown here are the plan drawings of the Point Cabrillo fog signal and light tower building as prepared in March 1908 by draughtsman A. G. Anderson and approved by Maj. C. H. McKinstry, of the U.S. Army Corps of Engineers, Engineer 12th Light House District. (Courtesy National Archives.)

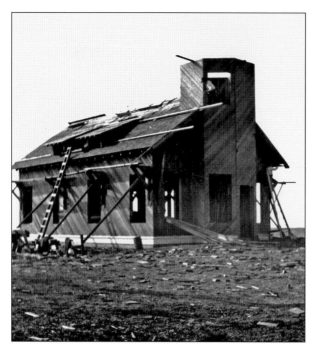

Construction was underway on the fog signal building and octagon-shaped light tower at Point Cabrillo, as shown here in early 1909. The building was unusual in its design, which resembled a small church or school structure and in the use of almost entirely wood construction materials, mainly local redwood and Douglas fir, or Oregon pine, as it was know at that time. (Courtesy U.S. Lighthouse Society.)

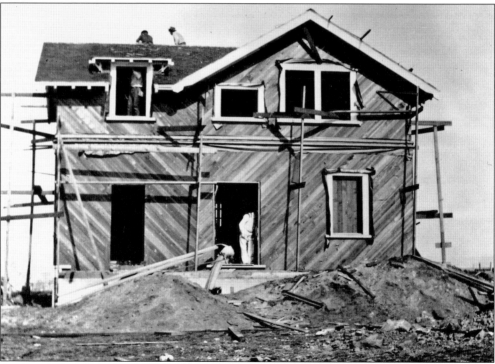

At the same time that the lighthouse was rising down on the bluffs, work was underway on the west assistant keeper's house, one of three Craftsman-style dwellings designed by the U.S. Army Corps of Engineers for West Coast light stations in the 1900s. The two-story structure had three bedrooms upstairs and a kitchen, dining room and parlor downstairs with a covered porch to the front and a laundry room at the rear. (Courtesy U.S. Lighthouse Society.)

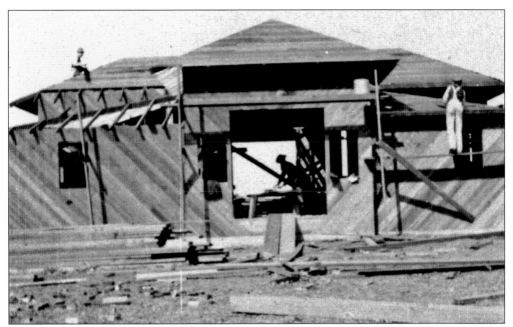

The keepers would need at least one horse and a wagon to bring supplies to the station and to provide transportation to the local communities. The station, therefore, included a barn to the south of the lighthouse. Here the structure is under construction in early 1909. The building provided ample space for harness, horse stalls, and for one or more wagons or buggies. (Courtesy U.S. Lighthouse Society.)

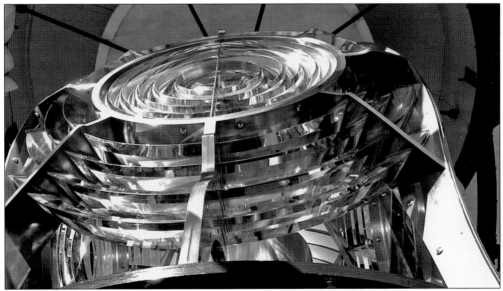

The third-order Fresnel lens for the Point Cabrillo lighthouse was ordered from the main British manufacturer of lighthouse equipment, Chance Brothers in Birmingham, England, in 1908 and was shipped around Cape Horn to San Francisco. At the U.S. Lighthouse Service depot at Yerba Buena Island in San Francisco Bay, the lens was assembled and was tested before being transported up the coast by a lumber schooner to Little River for installation at Point Cabrillo. (Courtesy PCLK.)

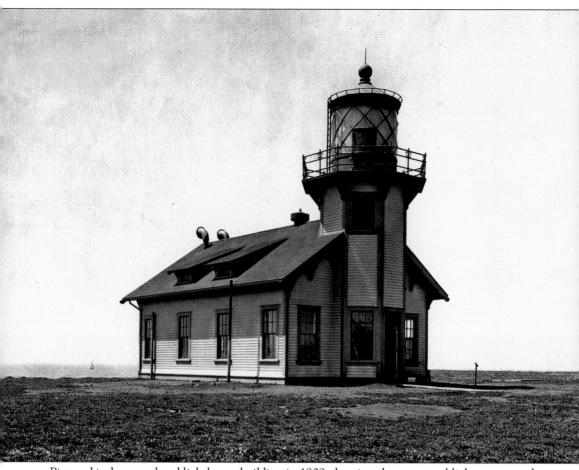

Pictured is the completed lighthouse building in 1909, showing the octagonal light tower on the landward end of the building with the lantern room and balcony at the top. Under the drawn lantern room drape is the new third-order Fresnel lens. Prior to automation in the 1970s, the light was only lit between sunset and sunrise. During daylight hours the light was extinguished, the clockwork turning mechanism was disengaged, and the heavy canvas drape was drawn by the keepers to protect the lens and light equipment form the direct rays of the sun. When the lens was not turning, the glass prisms would act like a giant magnifying glass and cause scorching of the fabric of the light and lens. The lens at Point Cabrillo rotated on a set of ball bearings turned by a clockwork drive. Fresnel lenses are graded by size from first order—the largest used in landfall lights like Point Arena and Point Reyes—down to the sixth order—the smallest size used in smaller harbor lights. The lens at Point Cabrillo had four bull's-eyes and 90 individual prisms set in a brass frame. The trumpets from the two sets of air horns of the fog signal can be seen on the far end of the building's roof. (Courtesy USCG.)

This is a drawing of a multi-wick oil lamp similar to the one that would have been installed at Point Cabrillo in 1909 as the light source. It was in use until 1911, when it was replaced by a pressurized oil vapor lamp. In 1935, electric power was brought to the light station, and the light source was then provided by a large, incandescent bulb. (Courtesy USCG.)

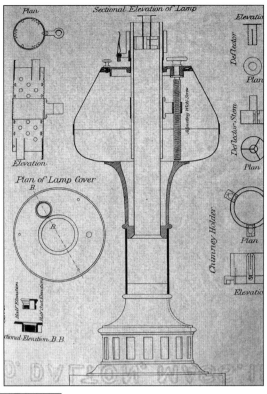

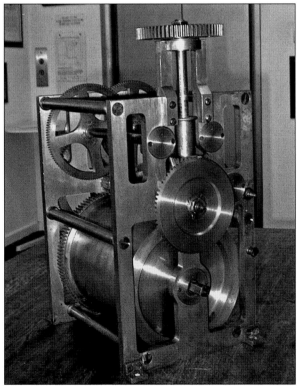

This photograph shows a clockwork mechanism used to turn a lens similar to the one installed in 1909 at Point Cabrillo and in use until electrification in 1935. The clockwork unit was mounted on the pedestal just below the lens and was connected to the turning rod on the lens by the drive gearing at the top of the unit (as seen at left). A wire rope with a heavy weight on the end was wound around the large, cylindrical drum using a handle crank operated by the keeper on duty. As the weight descended down the light tower, the clockwork drive completed one full revolution of the lens every 40 seconds, creating the signature white flash every 10 seconds. This signature identified the light to passing ships as Point Cabrillo and was so marked on charts of the coast. (Photograph by Bruce Rogerson, courtesy U.S. Lighthouse Society.)

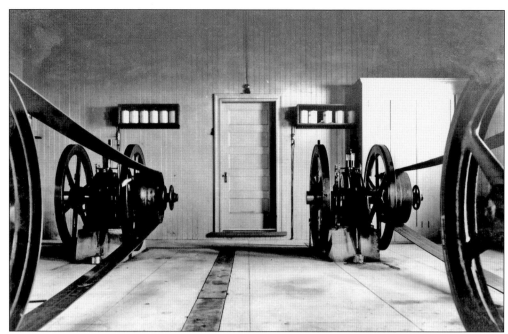

The main portion of the lighthouse building at Point Cabrillo was known to the keepers as the fog signal building. This large open room housed two sets of oil engines driving compressors and air receivers. The air receivers powered two first-class air sirens of the fog signal mounted on the western end of the roof of the building. (Courtesy PCLK and USCG.)

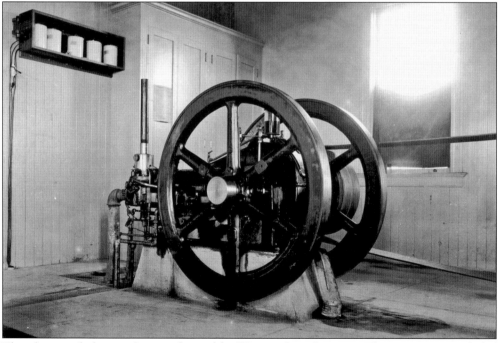

This photograph shows a close up of one of the Western Gas oil engines. These engines were fueled by gasoline. The fog signal consisted of a 2-second blast, 2 seconds of silence, a 2-second blast, 24 seconds of silence, and then the sequence was repeated. (Courtesy PCLK and USCG.)

This is a photograph of the smithy nearing completion in early 1909. This building provided the main workshop for the keepers and was critical in maintaining the light station buildings and machinery. The smithy contained a forge and blacksmith's shop, along with a carpenter's shop. (Courtesy U.S. Lighthouse Society.)

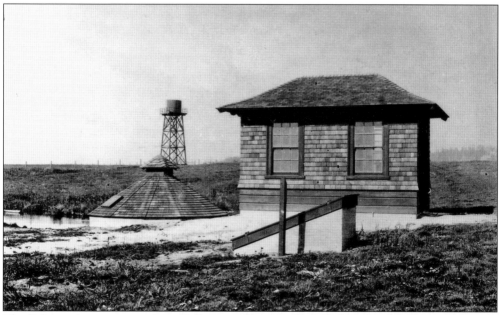

The light station water supply initially came from a well drilled south of the keepers' houses. Water was pumped from the well to the holding cistern on the left of the pump house with the conical wooden roof. From there, the water was pumped to the holding tank at the top of the water tower in the background to provide sufficient pressure for the supply going to the station buildings. (Courtesy USCG.)

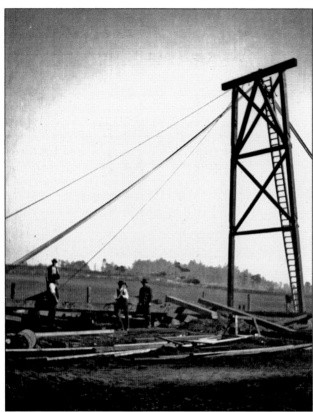

Work is shown underway in erecting the supporting frame for the water tower, which originally stood in the field 400 feet southeast of the keepers' houses. Water towers were typical in the local communities and were required to generate sufficient water pressure from the well-fed water systems of the day. Examples of water towers can be seen today in Mendocino village, located two miles south of the light station. (Courtesy U.S. Lighthouse Society.)

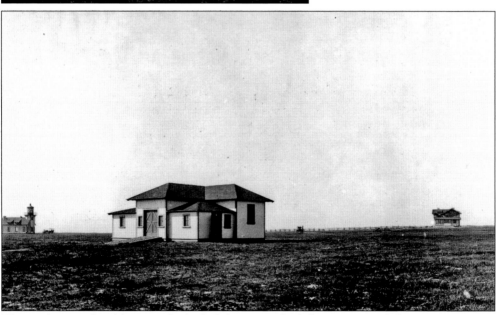

This is the completed barn, with the lighthouse to the left, or west, and the junior assistant keeper's house to the right, or east, in the background. The sloping ramp for the horses and wagons can be seen leading to the main door of the barn on the southwest side of the building. (Courtesy USCG.)

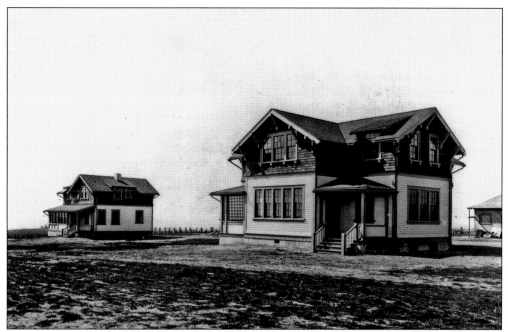

Pictured are the head keeper's residence on the right and the junior assistant keeper's house on the left, which is near completion in 1909. The chimney stacks still needed to be installed on both buildings, and construction was continuing on the coal house behind the main house at the right edge of the photograph. (Courtesy USCG.)

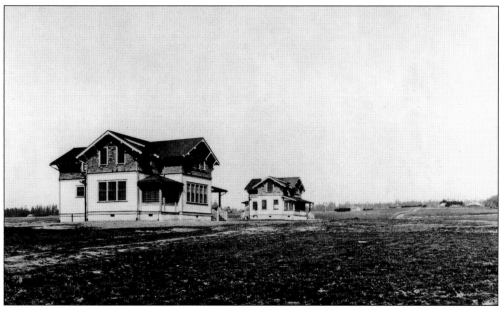

This shows the view looking inland and east up the hill to the community of Pine Grove on the distant horizon. The lighthouse road leading down to the station can be seen faintly in the middle of the photograph. The head keeper's house is closer to the camera, and the senior assistant keeper's house is beyond. (Courtesy USCG.)

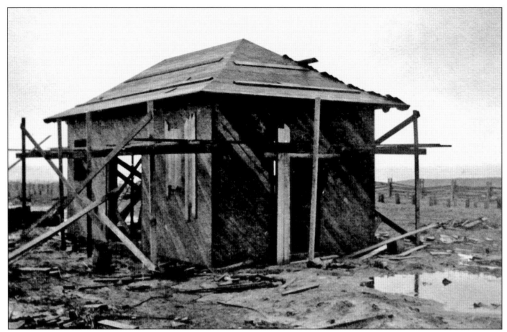

At the rear of each of the keepers' houses, a small building was constructed as a combined storage and workshop for each of the keepers and their families. Here is one of the buildings under construction in 1909. Coal was stored in one end, with the workshop in the middle and storage for garden tools and seed at the other end. (Courtesy U.S. Lighthouse Society.)

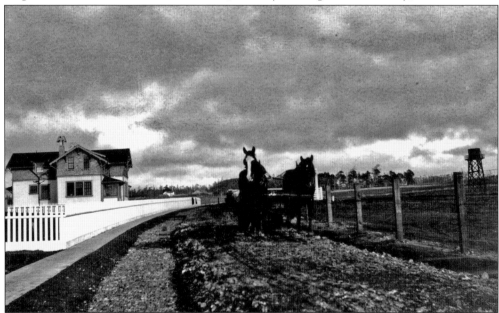

When construction of the station buildings was completed, the U.S. Army Corps of Engineers and the contractor finished the other site work, including new white Queen Anne–picket fencing around the gardens of the houses, sidewalks, and grading of the road down to the lighthouse. Here the contractor's horses and roller are working on the road surface. (Courtesy U.S. Lighthouse Society.)

Five

THE U.S. LIGHTHOUSE SERVICE YEARS
1909–1939

For more than 60 years, Point Cabrillo supported an active light keeper community during both the lighthouse service years from 1909 to 1939 and the U.S. Coast Guard jurisdiction from 1939 to the automation of the station in 1972 and beyond. The U.S. Lighthouse Service regarded Point Cabrillo as a married keeper's station, and both the principal keeper and first assistant keeper were expected to be married while serving at Point Cabrillo. The first head keeper, Wilhelm Baumgartner, was a bachelor when he arrived at Point Cabrillo. Early on, the district lighthouse superintendent hinted to him that Point Cabrillo was a married keeper's assignment. By 1911, Baumgartner had found a wife, who was the daughter of the local blacksmith in Mendocino village. Many of the keepers and their wives had children while serving at Point Cabrillo, and these children grew up at the station, enjoying a wondrous playground from the extensive gardens to the open fields and rocky shoreline of the station with great fishing and beachcombing.

Point Cabrillo was a popular station due to its proximity to the surrounding communities and services, including schools, and there was competition among the keepers to obtain a coveted posting to Point Cabrillo. The keepers in the early days of the lighthouse service received free housing, an annual supply of coal, and other basic supplies. Annual salaries ranged from $500 to $750, based on seniority.

Life at the station was challenging for both the keepers and their families. The keepers had long hours of duty maintaining the station and were on watch in the lighthouse overnight to ensure that the light was burning cleanly, the clockwork weight was wound up at regular intervals, and the fuel oil supply to the lamp was flowing smoothly. Prior to the installation of electrical power in 1935, there were few modern appliances to make life easier for the families. Cleaning and laundry required plenty of elbow grease, cooking was done on coal-fired cooking stoves, and it took hard work to produce the fine crops of vegetables and fruits that the light station gardens were noted for.

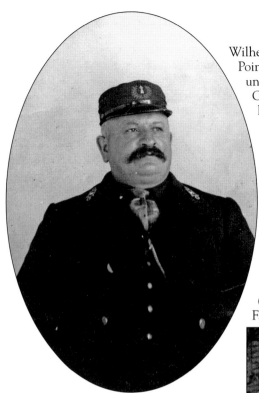

Wilhelm Baumgartner was the first head keeper at Point Cabrillo Light Station and held that position until his death in 1923. He was born in Bavaria, Germany, and immigrated to America in the late 1890s. He spent a short period in the U.S. Army and reputably served as bugler in the Spanish-American War. After leaving the army, he joined the U.S. Lighthouse Service in 1903 as a third assistant keeper at the remote and arduous St. George's Reef lighthouse, nine miles off the northern California coast at Crescent City. He also served as first assistant keeper at the East Farallon and Point Conception lighthouses before being appointed as head light keeper for the new light station under construction at Point Cabrillo on the rugged Mendocino coast in February 1909. (Both, courtesy PCLK, from the Baumgartner Family Collection.)

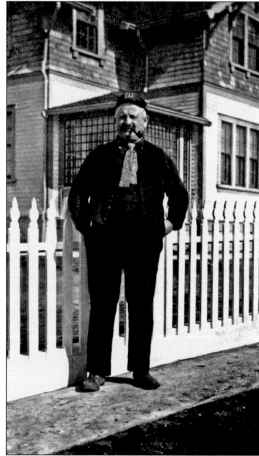

THE MENDOCINO BEACON

VOL. XXX. MENDOCINO, MENDOCINO CO., CAL., JUNE 12, 1909 NO. 36

Bellows Officially—Point Cabrillo Begins Its Career

In order to adorn the pages of history with a record of the official start, and to mark the time with some incident worthy of the occasion, the Point Cabrillo light and fog station was started Wednesday night by a gathering of people at the home of Head Keeper Baumgartner for a social good time. Wednesday was the date set by Major McKinstry in charge if the 12th lighthouse district, and the fog was good and thick on the night of that date so there was ample excuse for putting the fog horn to work, and permitting the "gentle zephyrs" to waft the "soft strains" of the symphonious horn to the rhythmical ears of the sleeping residents within a radius of a half score miles. The fog was too dense for the light to penetrate very far, but the horn bellowed loud enough to make up for it. The start was made at the hour of midnight. William Baumgartner, chief lighthouse keeper, sent out invitations to all the neighbors within a radius of a mile or so to be present at the official start-up of the light and signal. After everything was started and fairly well underway the guests, to a number or 30 or 40, were invited to partake of a midnight super. The collation, which was prepared by Mrs. G. E. Bassett, wife of the first assistant keeper, was bountiful and unusually appetizing. The guests expressed themselves as having had a most enjoyable time.

From the *Mendocino Beacon*, June 12, 1909

(Above, courtesy the *Mendocino Beacon*; below, courtesy PCLK and USCG.)

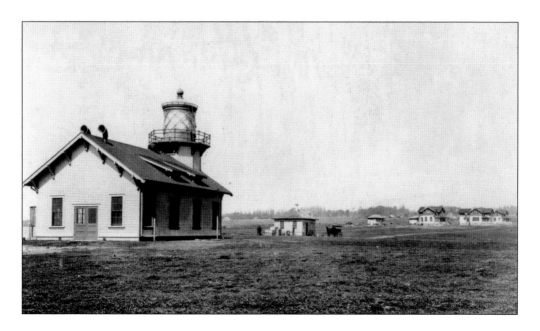

This is the future Mrs. Baumgartner on the steps of the keeper's house. Head keeper Wilhelm Baumgartner was a bachelor when he accepted the appointment to Point Cabrillo. Early on, the district superintendent hinted to him that Point Cabrillo was considered a married keeper's assignment. By 1911, Baumgartner had married Lena Seman, the daughter of the blacksmith in nearby Mendocino Village. (Courtesy PCLK and Susan Pritchard O'Hara.)

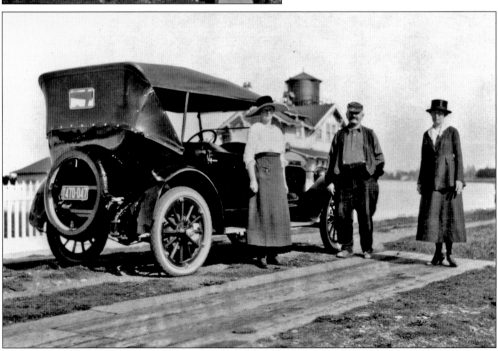

This photograph is of keeper Wilhelm Baumgartner, his wife, Lena, and a friend outside the keepers' houses with a 1920s automobile. (Courtesy PCLK, from the Baumgartner Family Collection.)

Assistant keeper Al Scott's daughter Martha sits in a chair in front of the fireplace in the dining room, which looks like it appears today in the restored first assistant keeper's house at Point Cabrillo. (Courtesy PCLK, from the Baumgartner Family Collection.)

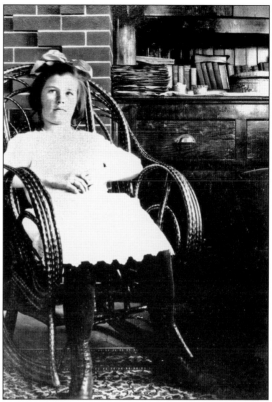

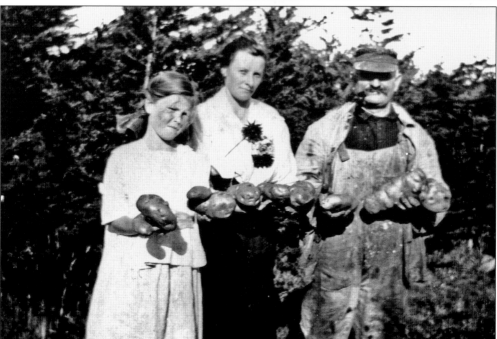

Wilhelm Baumgartner, his wife, Lena, and a young friend show off the fine potatoes from the light station gardens in the 1920s. (Courtesy PCLK and Susan Pritchard O'Hara.)

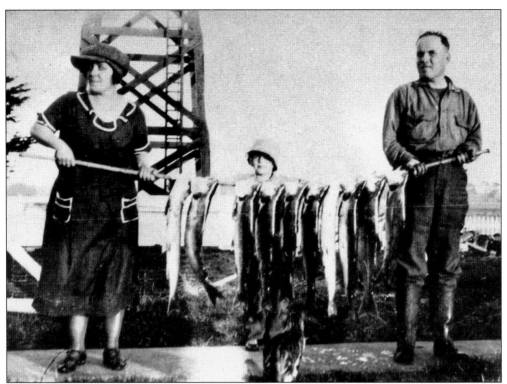

The Telgard family is shown with a fine catch of fish from the waters off Point Cabrillo in the 1920s before the days of marine preserves and catch limits. (Courtesy PCLK, from the Marty Telgard Collection.)

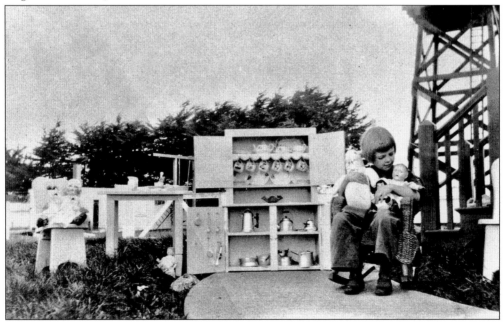

Marty Telgard is shown playing with her dolls and dollhouse outside the back steps of the senior assistant's house in the 1920s. (Courtesy PCLK, from the Marty Telgard Collection.)

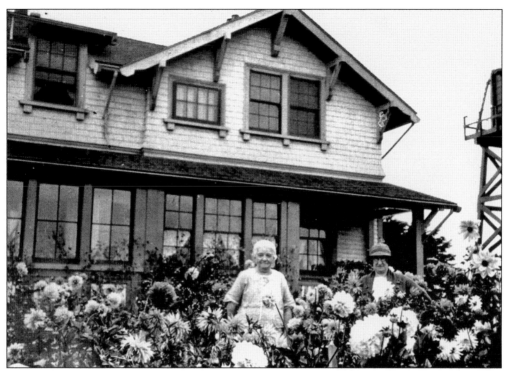

Keeper Martin Telgard's mother and his wife, Caroline (right), stand in the front garden of the senior assistant keeper's house in a profusion of chrysanthemum flowers. (Courtesy PCLK, from the Marty Telgard Collection.)

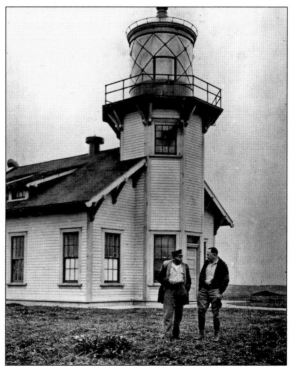

Pictured here is head keeper James Simonsen (left) with James D. McClure, a representative of the National Geographic Society, in front of the lighthouse in 1929. (Courtesy PCLK and Kelley House Museum.)

Young Russell (Harry Jr.), son of assistant keeper Harry Miller, lived at Point Cabrillo from 1935 to 1946. This photograph, with one of the keeper's pet cats, was taken at the Point Sur Light, where his father was stationed before coming to Point Cabrillo. (Courtesy Geene Miller.)

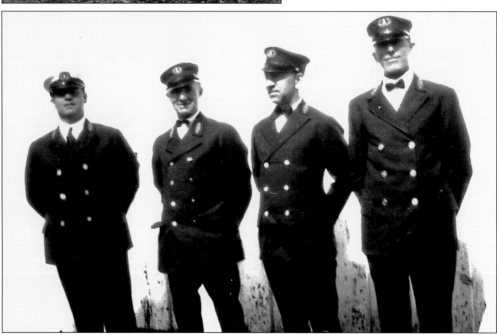

A group of U.S. Lighthouse Service keepers in their dress uniforms are shown here in the 1930s. Assistant keeper Harry Miller is the man on the right. The other keepers, from left to right, are William Mollering, Bill Fraser, and ? McGonegal. (Courtesy California Department of Parks and Recreation.)

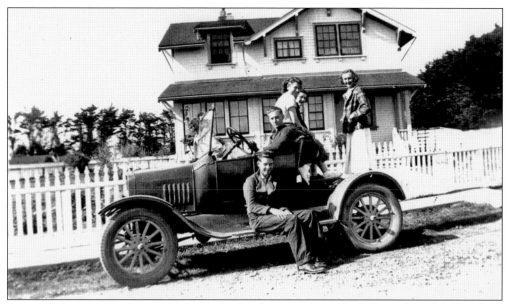

Pictured here are assistant keeper Harry Miller daughters Leota and Hannah with high school friends on an automobile outside the senior assistant keeper's house in the late 1930s. (Photograph by David Samuels, courtesy PCLK.)

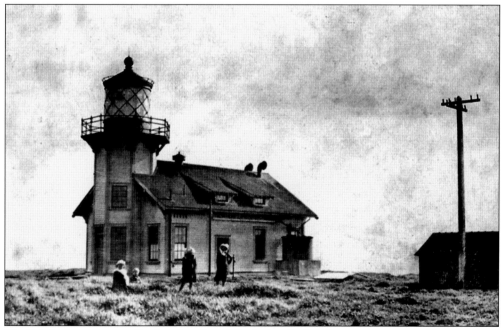

The lighthouse was generally closed to the public during the lighthouse service years. However, once a month, usually on a Sunday, the keepers would open the light station to visitors. Photographed here are some ladies posing in front of the lighthouse building in the early 1910s. (Courtesy Kelley House Museum.)

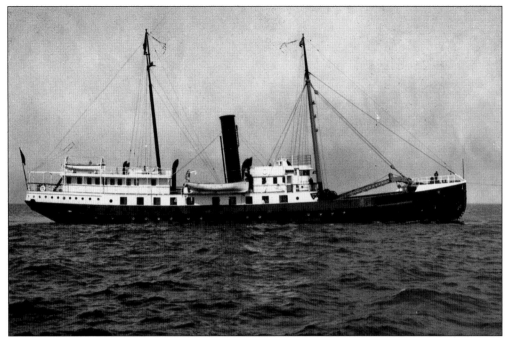

This is the 12th district light tender *Sequoia* under way off the California coast. The light tenders were used to maintain aids to navigation along the northern coast of California and San Francisco Bay, and were based at the U.S. Lighthouse Service depot on Yerba Buena Island. These ships were also used to deliver personnel and supplies of coal, kerosene, and other materials to the light stations along the coast. (Courtesy U.S. Lighthouse Society.)

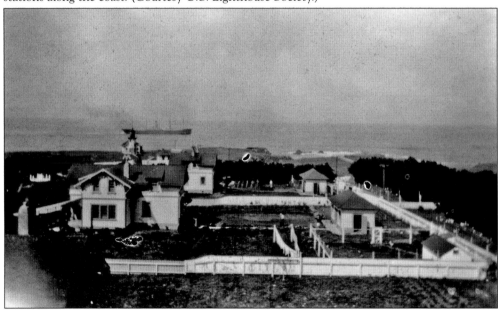

This image shows a view of the light station, probably in the early 1920s, taken from the top of the water tower after it was moved closer to the east assistant keeper's house, looking west over the gardens. An ocean-going cargo vessel can be seen in the background steaming north, probably to load lumber in Noyo Bay. (Courtesy Kelley House Museum.)

A U.S. Lighthouse Service five-gallon can was used by the keepers to carry the supply of kerosene from the oil house to fill the oil tank in the lantern room that supplied the original multiple-wick light. In 1912, keepers began using the pressurized oil vapor Type-A 55-millimeter kerosene single-mantle lamp. (Courtesy U.S. Lighthouse Society.)

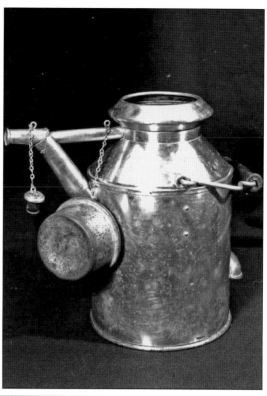

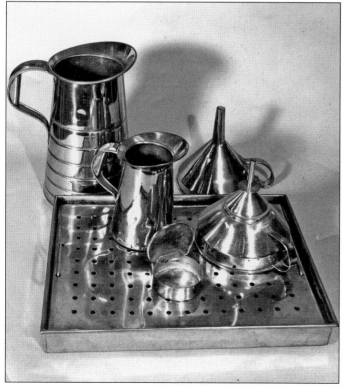

Here are some of the other keeper's tools of the trade of that would have been used at Point Cabrillo from 1909 to 1935, when the source of the light was converted from kerosene oil to electricity. Most of these brass tools would have been manufactured at the main lighthouse service depot on Staten Island, New York. (Photograph by Herb Kynor, courtesy U.S. Lighthouse Society.)

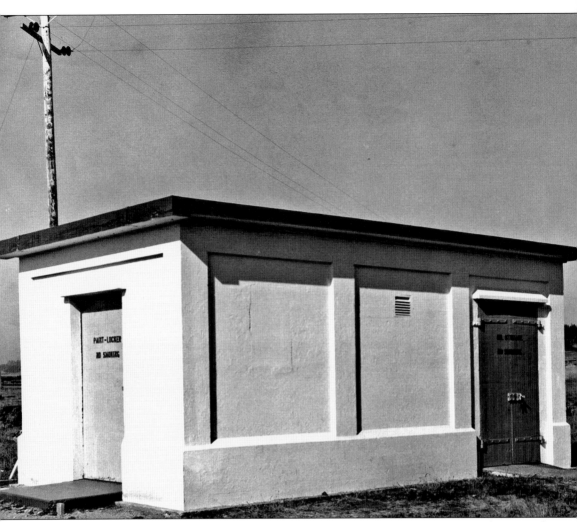

The concrete oil house at Point Cabrillo was used to store kerosene oil and gasoline in large metal tanks from 1909 to 1935. The oil was delivered by wagon in barrels, which had been brought to Mendocino or another nearby landing by the lighthouse tenders, and these were then rolled up a ramp at the rear of the building, and the oil was transferred to the holding tanks in the building. The can shown on page 65 was then used by the keepers to transfer the oil from the tanks in the oil house to fill the reservoir in the lantern room for the oil lamps. From the 1930s to the 1970s the oil house was used for paint storage. (Courtesy PCLK and USCG.)

Six

POINT CABRILLO'S NEIGHBORS

Lighthouse Road, with its white fencing on either side, ran up the slope from the light station at Point Cabrillo east to meet the old county highway now known as Point Cabrillo Drive. At the time the lighthouse was opened, there was a thriving rural community along this road known as Pine Grove, with a history of settlement dating back to the early 1850s. Most of the residents worked on local farms or in the lumber mill at Caspar. In its heyday, this small community included a general store, several taverns, a hotel, a brewery, and a racetrack where the locals raced their horses and ponies on the weekends and holidays.

The county road leads north less than a mile to the lumber mill and the town of Caspar. The mill and extensive forestlands were owned by the Jackson family. The mill was operated from 1867 until it closed it 1955. The lumber products from the mill were shipped by sea from the Caspar anchorage and bay adjacent to the mill and township.

Two miles south of Point Cabrillo lay the burgeoning community of Mendocino, dating back to 1852 and the arrival of the vessel *Ontario* with the equipment for the first lumber mill on the coast. By 1909, Mendocino City, as it was sometimes known, was a bustling center of shops, taverns, and local tradesmen, all supporting the lumber industry and the local residents. The village featured many fine homes built during the late 19th century by the newly prosperous mill owners, ship captains, and business entrepreneurs.

Six miles to the north of Point Cabrillo stood the city of Fort Bragg, which grew up in the late 1880s around the Union Lumber Company mill just north of the Noyo River mouth. The Union Lumber Company became the largest exporter of redwood lumber products in the region during the early years of the 20th century, with the city of Fort Bragg gradually eclipsing Mendocino Village in population and as a business and commercial center.

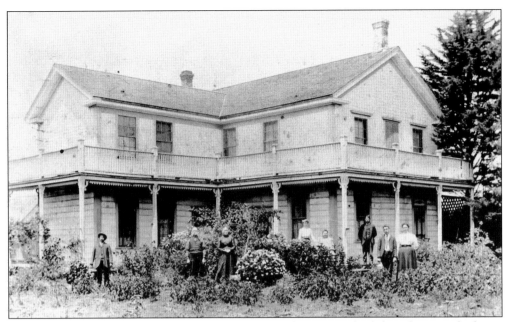

This building in Pine Grove was the Pine Grove Hotel in 1903, which later became the home of the Gordon family. The figures in the photograph are, from left to right, Fritz Waschter, a local brewer; David Gordon, a farmer who owned the land the lighthouse was built on; Margaret Gordon; Bertha Sass Brinzing; Margaret Brinzing; Martin Brinzing Sr.; Angus McDonnell; and Lillian McDonnell. (Courtesy PCLK and Susan Pritchard O'Hara.)

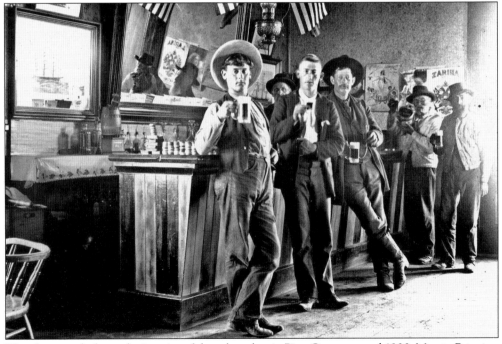

The photograph shows the interior of the saloon bar in Pine Grove around 1900. Martin Brinzing is the figure in the front, third from the left, with his legs crossed and a mug of beer in his hand. He owned the local brewery and the bar. (Courtesy PCLK and Susan Pritchard O'Hara.)

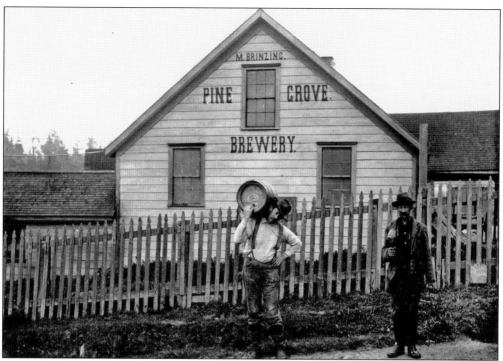

This shows the exterior of the Pine Grove Brewery in the 1890s, with owner Martin Brinzing holding the keg of beer and brewer Fritz Waschter on the right. (Courtesy PCLK and Susan Pritchard O'Hara.)

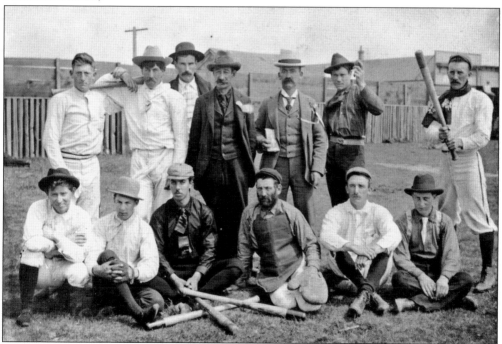

The local baseball team from Caspar is pictured here about 1900. The individual members of the team are not identified. (Courtesy PCLK and Susan Pritchard O'Hara.)

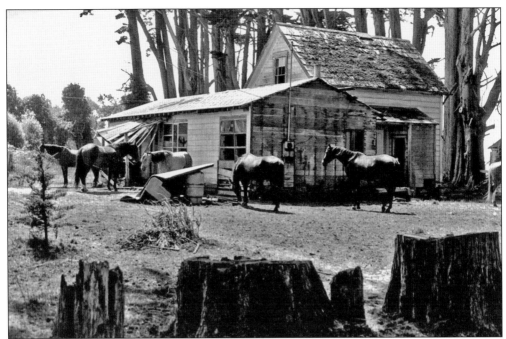

The McDonald-Kearns farmhouse, dated from the 1870s, was the last remaining building in the Pine Grove community. This photograph was taken in the 1980s. The small two-story building in the rear of the image was destroyed by fire in 2000 and is now the site of the visitor center at the entrance to the Point Cabrillo Light Station State Historic Park. (Courtesy Nancy Barth.)

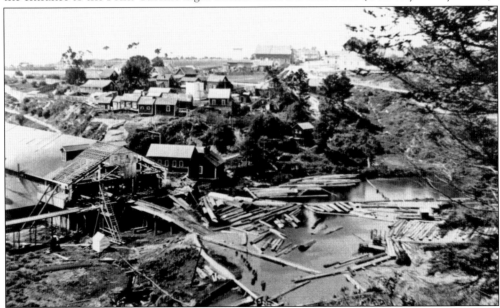

This photograph shows the Caspar Lumber Company mill in the 1890s, with the Caspar village buildings on the hillside above the main mill building and log pond. The mill was expanded in later years and continued operation despite some closures during the Depression until 1955. Martin Telgard retired from his career as a light keeper at Point Cabrillo in 1926 and worked as an engineer at the mill for many years. (Courtesy Kelley House Museum.)

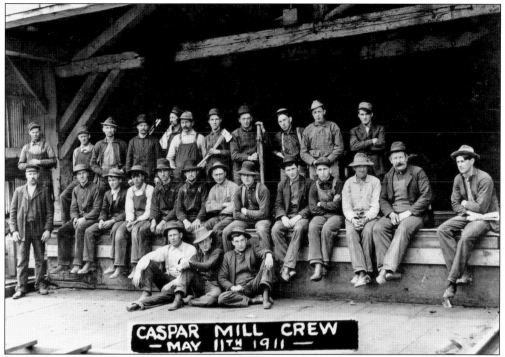

This is the Caspar Lumber Company mill crew in 1911. Martin Brinzing, owner of the Pine Grove Brewery, is in the second row, second from the right. (Courtesy PCLK and Susan Pritchard O'Hara.)

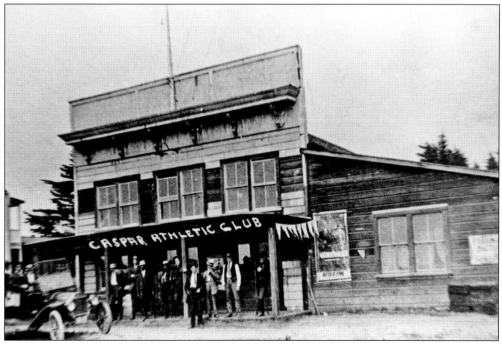

The Caspar Athletic Club building is shown in the early 1920s. The club fielded a baseball team and provided the men from the mill with recreational facilities. (Courtesy Kelley House Museum.)

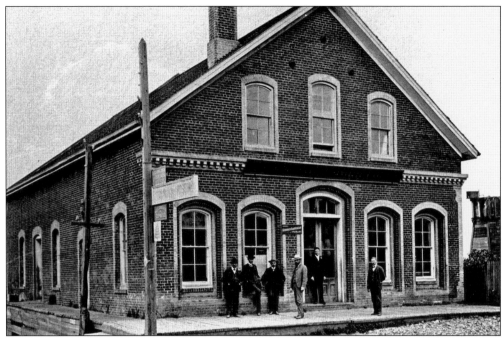

Characteristic of many lumber communities on the coast, the local mill provided a company store that supplied groceries, hardware, and dry goods to the local residents. In the early days, the mills controlled the sales by requiring the workers to spend their pay chits at the company store, but this was subsequently outlawed in the state. (Courtesy Kelley House Museum.)

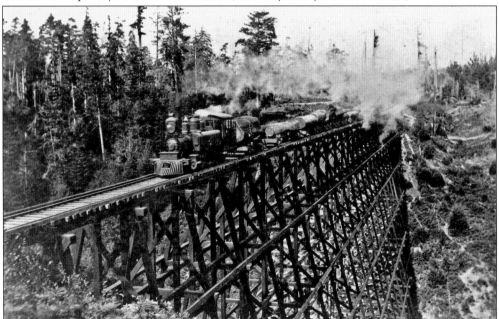

The Caspar Lumber Company operated one of the most extensive logging railroads in the county moving huge redwood logs from the woods to the mill. In the photograph, a logging train is crossing the massive Jughandle Creek Trestle in the early 1900s. This trestle was destroyed in the 1906 earthquake and had to be rebuilt. (Courtesy PCLK and Susan Pritchard O'Hara.)

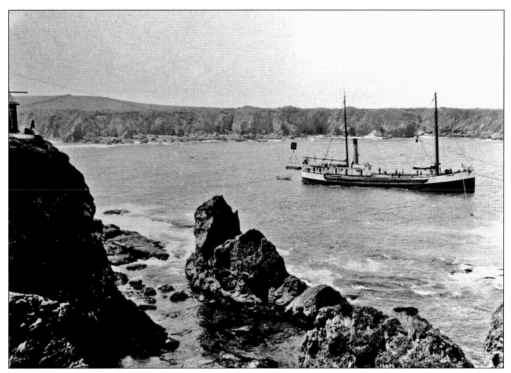

The steam schooner *Samoa* is pictured loading lumber under the wire at the Caspar anchorage in the 1900s. The *Samoa* was wrecked at Point Reyes in 1913. (Courtesy Kelley House Museum.)

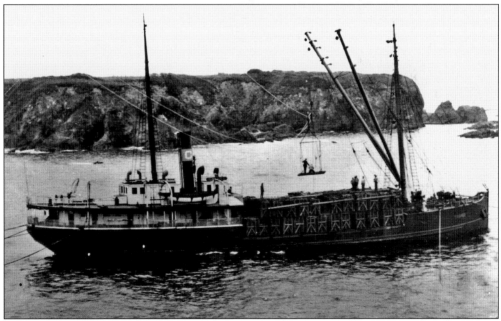

The Caspar Lumber Company also operated its own small fleet of steam schooners for many years. Here the *Caspar*, the last of the fleet and the third steam schooner of that name, is completing the loading of a cargo of rail ties for Mexico in the 1920s. Larger ocean-going freighters also loaded under the wire at the Caspar mill until the late 1930s. (Courtesy Kelley House Museum.)

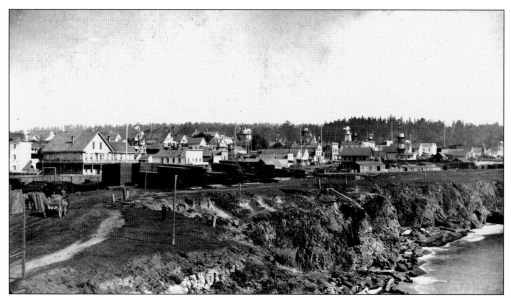

This is a panoramic view of Mendocino Village in the 1890s, taken from the bluffs southwest of the village. In the foreground is the lumberyard that supplied the loading wire chutes to the steam schooners, which were located behind the photographer. (Courtesy Kelley House Museum.)

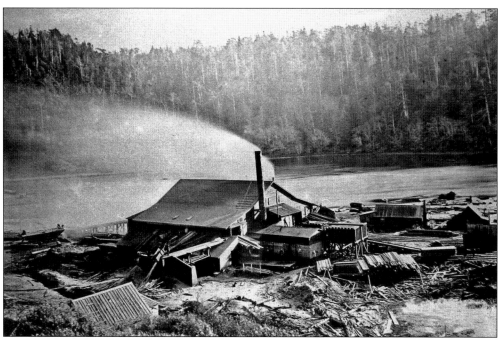

This photograph shows the second mill at Mendocino, c. 1865, located on the Big River Flats east of the village. (Courtesy FB-MCHS.)

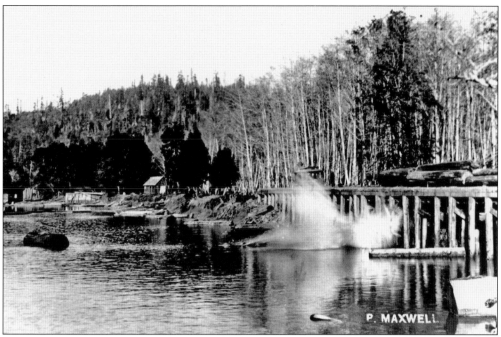

Logs for the Mendocino mill were brought out of the woods by oxen teams in the early days and later by logging trains to the Big River, where they were floated down to the mill. Here logs are dropped into the water at the Big River Flat Log Pond. (Photograph by Perle Maxwell, courtesy Kelley House Museum.)

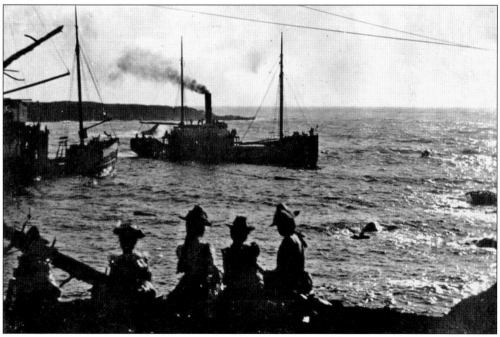

Watching the comings and goings of the steam schooners at the doghole ports on the Mendocino coast was a popular pastime for locals. Photographed here are some ladies on the shore watching two steam schooners maneuvering in Mendocino Bay in the 1900s. (Courtesy Kelley House Museum.)

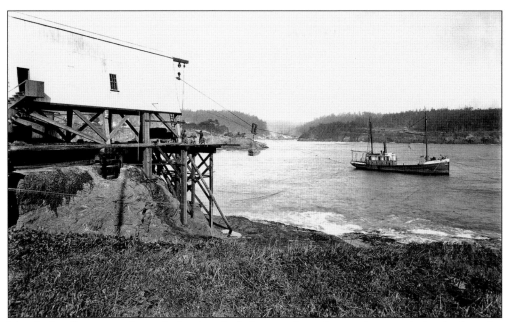

Mendocino Bay was perhaps the busiest doghole port along the north coast dating back to the earliest days of the lumber trade. Here the steam schooner *Phoenix* is under the wire receiving cargo in 1913. Remains of the foundation of the wire chute house on the bluff on the left can still be seen today at the Mendocino Headlands State Park. (Courtesy San Francisco Maritime National Historical Park.)

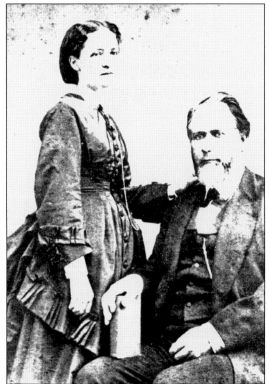

This is a photograph of Jerome Ford and his wife, Martha, from the 1870s. Jerome Ford was born in Grand Island, Vermont, and came to California in 1849. Ford came north during the spring of 1851 in search of the *Frolic* wreck. He found little to salvage but was convinced that greater treasure lay in the virgin redwood trees lining the rivers and hills of coastal Mendocino. (Courtesy Kelley House Museum.)

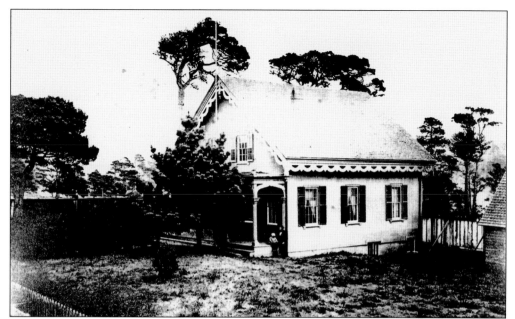

The Ford House, the first house of Jerome Ford and his family, is photographed here around 1863. The house was added on to and expanded over the years. Today the house is part of the Mendocino Headlands State Park and houses a museum and gift shop run by the Mendocino Area Parks Association. (Courtesy California State Parks, from the Watkins Photograph Collection, Bancroft Library.)

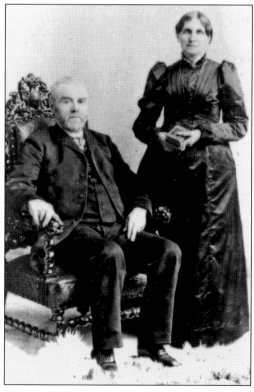

Pictured are William Kelley and his wife, Eliza Kelley. William Kelley was born in Prince Edward Island, Canada, in 1821. He came to California in 1850. After working as a shipbuilder in Benicia, he signed on with the crew of the brig *Ontario* as a carpenter and found himself on the coast of Mendocino at the opening of the first lumber mill. (Courtesy Kelley House Museum.)

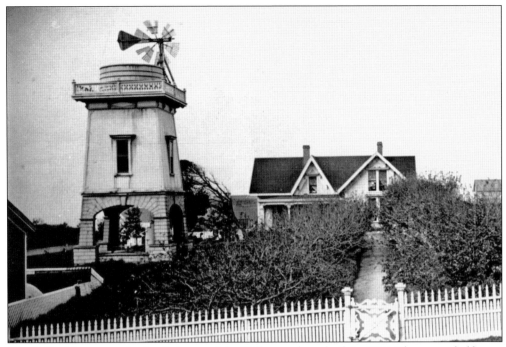

The Kelley House was the family home of the Kelleys and was built in 1861. The expanded house was left to the community in the 1950s and now houses the Kelley House Museum and local historical research center on Albion Street in the village. (Courtesy Kelley House Museum.)

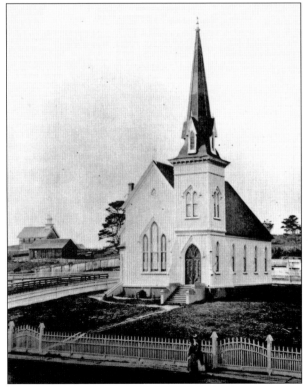

Mendocino Presbyterian Church is one of the oldest Presbyterian churches in California, dating from 1858. A major place of worship in the village for 150 years, the building is constructed of redwood and was dedicated on July 5, 1868. (Courtesy Kelley House Museum.)

Head keeper Wilhelm Baumgartner is shown in an early automobile in Mendocino, c. 1910, with the Mendocino Hotel in the background. (Courtesy PCLK, from the Baumgartner Family Collection.)

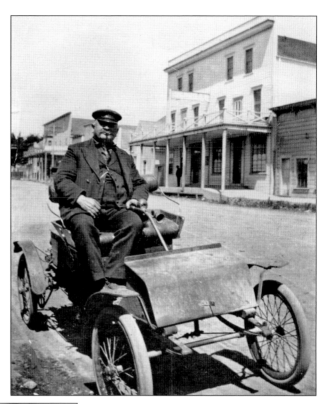

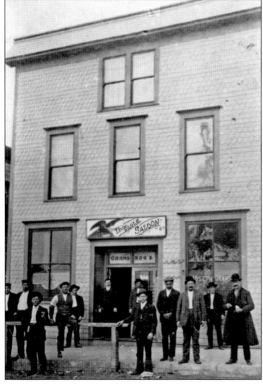

In the early 1900s, the Granskogs Eagle Saloon in Mendocino was a popular watering hole for the mill workers and the men from the lumber camps to go to on their days off. (Courtesy Kelley House Museum.)

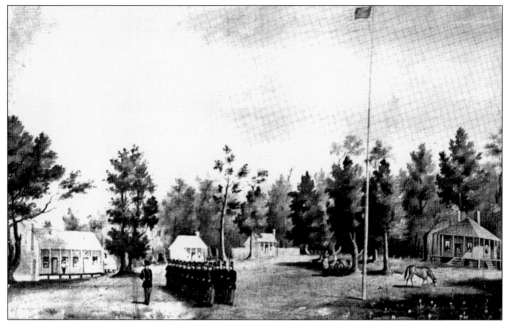

There was a military fort at Fort Bragg from 1857 to 1864 with up to a company of federal troops stationed there to keep order between the white settlers and the Pomo. Following the transfer of the Pomo from the reservation north of the Noyo River inland to the Round Valley Reservation, the fort was abandoned. The fort was named by its first commanding officer, Lt. Horatio Gibson, in honor of his mentor and commanding officer during the Mexican-American War, Col. Braxton Bragg. Seventy years later, Gibson, now retired from the army, was given the honor of naming the new training base in North Carolina. He again chose to name it after Bragg, who fought for the Confederate states, reaching the rank of major general. The illustration of Fort Bragg is from an original painting from 1858 by Robert Edouart. (Courtesy FB-MCHS.)

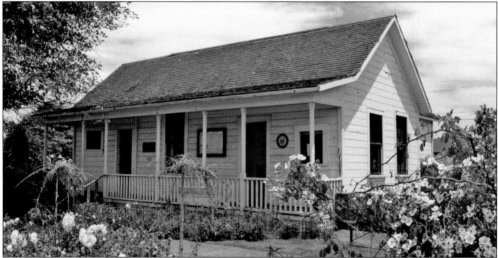

Only one building from the original fort has survived. This photograph shows the building as it appears today on North Franklin Street in Fort Bragg. The building was the quartermaster's store building and commissary in the fort from 1857 to 1864 and now serves as the local office of the congressman for this district. It was moved from its original location to its present site in 1986.

This is a portrait of Lt. Horatio G. Gibson, first commanding officer at Fort Bragg in Mendocino County in 1857–1858. (Courtesy FB-MCHS.)

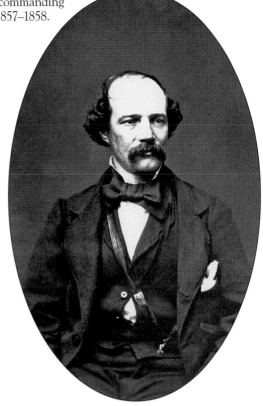

The first mill was located at the mouth of the Noyo River. It was owned by Macpherson and Wetherbee in 1863. The mill was eventually absorbed into the Union Lumber Company in 1891. (Courtesy FB-MCHS.)

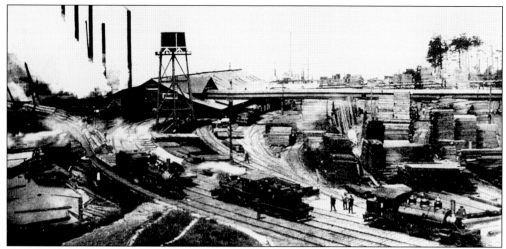

In the 1880s, C. R. Johnson, a lumberman from Wisconsin, moved to the coast and founded the Union Lumber Company. A new mill was constructed on the bluffs north of the Noyo River, and the company town of Fort Bragg grew around it. This photograph shows the mill in 1910 with its network of rail lines—some still exist and are part of the California Western Railroad. (Courtesy FB-MCHS.)

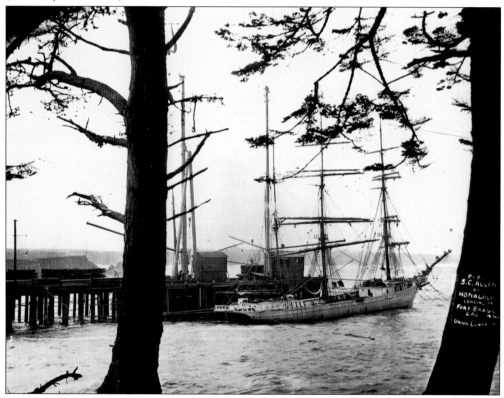

C. R. Johnson built a wharf in Fort Bragg harbor about one mile north of the Noyo River entrance where both steam lumber schooners and larger vessels could load close to the mill. The wharf was approached through a narrow channel that had reefs on either side, which demanded boat handling of a high caliber. (Courtesy FB-MCHS.)

Pictured above is a view of the railroad station in Fort Bragg in 1907. The railroad served the mill by bringing in logs from the woods and provided passenger service to communities along the Noyo River. In 1911, the railroad was extended 35 miles inland to Willits, where it connected with the Northwestern Pacific Railroad. The photograph below shows the first train from Fort Bragg to Willits arriving at Willits on December 19, 1911. Passengers were able to travel through by rail to San Francisco and all across the country by train. The advent of this rail connection and the introduction of the automobile were partly responsible for the reduction in the number of passengers on the coastal steamers during the next 20 years. (Both, courtesy FB-MCHS.)

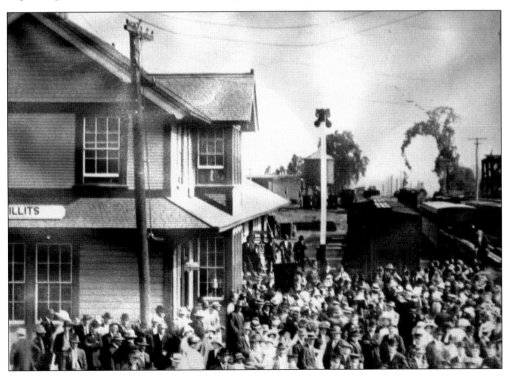

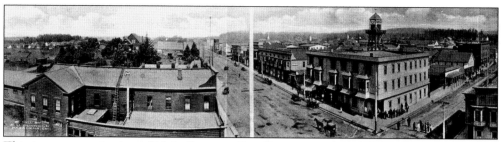

This is a panoramic view of Main Street in Fort Bragg around 1911. The town of Fort Bragg took its name from the original fort, established in 1857. Some of the old army buildings still remained and were occupied by C. R. Johnston and the early inhabitants of the town. The city was incorporated in 1889, and its first mayor was Johnston, the owner of the Fort Bragg Redwood Company, which in 1891 became the Union Lumber Company. The lumber mills were the major employers, followed by the fishing industry in nearby Noyo River and companies supplying the mills and lumber camps in the nearby woods. Many of the early inhabitants were immigrants from the Scandinavian countries, particularly Finland and Portugal. Today the lumber industry is almost gone from the town, and the commercial fishing out of Noyo Harbor is a mere shadow of its earlier years. The community relies on tourism and the associated service industries as its principal economic base in the 21st century. (Courtesy FB-MCHS.)

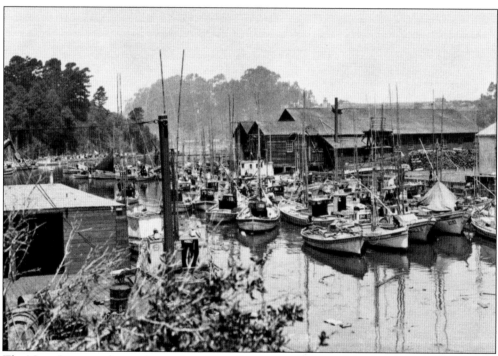

The Noyo River on the southern edge of Fort Bragg provides one of the few sheltered harbors on the long coast of Northern California. A large and prosperous fishing industry developed there in the early 1900s. This 1920 photograph was taken of the harbor at Noyo when it was packed with Monterey-style fishing boats during the height of the salmon-fishing season. The local fishing boats also caught rockfish, crab, and, in later years, tuna and shark. Many of the early fishing families were Finnish, Portuguese, and Italian immigrants. (Photograph by Wonacott, courtesy FB-MCHS.)

In the 1906 San Francisco earthquake, Fort Bragg suffered extensive damage because of its proximity to the San Andreas Fault, which runs approximately four miles off shore, parallel to the coastline. A fire started in the collapsed buildings, and the town center was only saved from destruction by the steam lumber schooner *National City*, which was moored at the Fort Bragg Wharf. The fire department hooked up their hoses to the vessel and enough water was pumped from the ocean using the ship's steam pump to control the fires. (Both, courtesy FB-MCHS.)

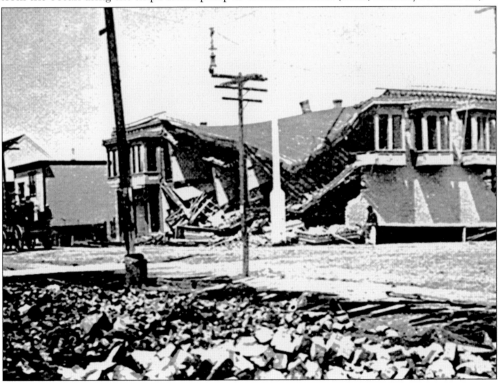

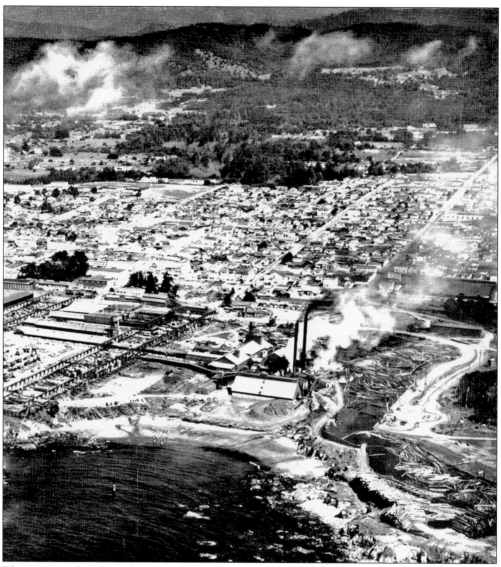

This image, taken from the air in 1952, shows the Union Lumber Company mill. The company was sold in 1969 by the Johnson family to the Boise Cascade Lumber Company and then to the Georgia Pacific Lumber Company in 1973. Georgia Pacific closed the mill in 2002, ending 125 years of lumber mill operations in Fort Bragg. (Photograph by Clyde Sunderland, courtesy FB-MCHS.)

Seven

THE U.S. COAST GUARD YEARS
1939–1991

In 1939, as part of the New Deal, Pres. Franklin D. Roosevelt decided to merge the U.S Lighthouse Service with the U.S Coast Guard. Over time, the civilian light keepers who retired or left the service were replaced by U.S. Coast Guard petty officers, seamen, and engineers at the active U.S. lighthouses.

At Point Cabrillo in 1939, head keeper Thomas Atkinson continued to serve until his death in 1950. He was assisted by U.S. Lighthouse Service assistant keepers in the first few years and then by coast guardsmen. By the 1950s, all the keepers at Point Cabrillo were U.S. Coast Guard personnel. However, in 1953, Bill Owens, one of the U.S. Lighthouse Service keepers, was transferred from the Point Arena lighthouse to serve as head keeper at Point Cabrillo until his retirement in 1963. He was the last of the civilian lighthouse service head keepers at a U. S. lighthouse.

During the World War II years at Point Cabrillo, the station expanded with the addition of a naval and coast guard detachment that was responsible for monitoring vessel traffic on the coast and provided shore patrols along the coastline of Mendocino County. A radio watch room was constructed just north of the lighthouse building, and several tall radio masts were installed nearby. A Quonset hut was built abutting the smithy to provide barracks for the naval ratings. The smithy was used as the galley and mess hall for the men.

By the end of the 1960s, the station was being prepared for automation, which occurred in the early 1970s with the installation of the new DCB beacon and decommissioning of the classical Fresnel lens. The last U.S. Coast Guard keepers left in 1972, and for a time, the houses were boarded up and left unoccupied. In the late 1970s, the houses were opened up and further modified to provide accommodations for the crews of the U.S. Coast Guard cutter *Point Ledge* based at Noyo Harbor in Fort Bragg. This arrangement ended in 1991, when the light station was transferred to the State of California and the crews were moved to new housing in Fort Bragg.

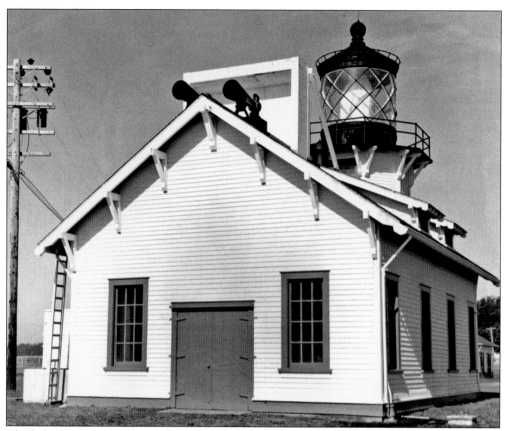

The lighthouse and fog signal building are shown in this *c.* 1940 photograph. Note the wooden baffle behind the foghorn trumpets on the roof, which was used to reduce the amount of sound inland toward the houses. These did little to reduce the sound impact of the foghorn, which was still bone rattling in intensity. The power poles that brought electricity to the building are on the left. (Courtesy PCLK and USCG.)

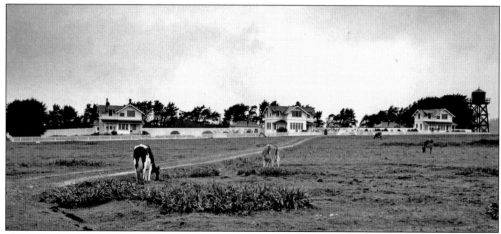

Shown here are the keepers' houses from the south, looking across the pasture with cattle grazing. The keepers kept cattle for milk and meat over the years at Point Cabrillo and also leased out the pasture to neighboring farmers. (Courtesy PCLK and USCG.)

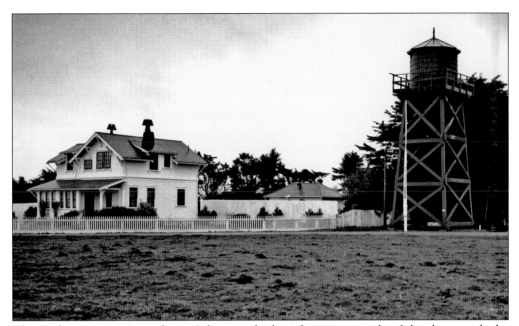

This is the senior assistant keeper's house, which is the most easterly of the three, with the water tower. The houses were painted white on both the upper and lower courses with red roofs to comply with the U.S. Coast Guard color schemes. About 1920, the water tower was moved from its original location in the field south of the houses to the pictured location. It was finally dismantled in the 1950s. (Courtesy PCLK and U.S. Lighthouse Society.)

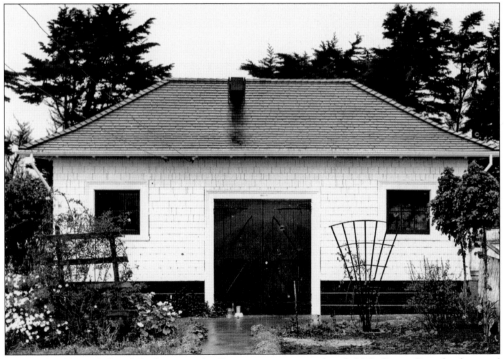

The outbuildings behind the keepers' dwellings were repainted with U.S. Coast Guard colors and were modified to be used as garages for the keepers' automobiles. (Courtesy PCLK and USCG.)

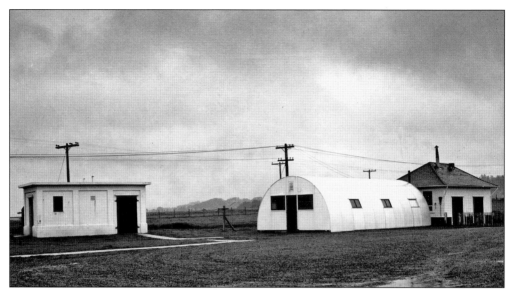

During World War II, a navy and coast guard detachment was stationed at Point Cabrillo to patrol the coast and report on shipping movements. A Quonset hut was built abutting the smithy to be used as the barracks for the navy personnel. The smithy served as the galley and mess room for the men. The Quonset hut was removed in the early 1950s. (Courtesy PCLK and USCG.)

This photograph was taken on April 20, 1940, when Hannah Miller (second from right) married Robert Purcell, a local man (far right). Her sister Leota (second from left) was already married to Robert's brother Clarence Purcell (far left). The pastor of the Fort Bragg Presbyterian Church, Rev. J. L. Kent, is in the center. The photograph was taken in the front garden of the senior assistant keeper's house. Leota and Hannah were the daughters of keeper Harry Miller. (Courtesy PCLK and Robert Purcell.)

Thomas Atkinson was the head keeper at Point Cabrillo from 1939 until his death in 1950. This photograph of his children was taken in the garden of the head keeper's residence in the 1940s. From left to right are sons Clarence and Carl, and daughters Flora, Mildred, and Deplha, who was born at the East Farallon light. (Courtesy Flora Gordon.)

Flora Atkinson grew up at Point Cabrillo during the war years and married Edward Gordon in 1947. Edwards's uncle, David Gordon, owned the land that the light station was built on and which he sold to the lighthouse service in 1908. Flora Gordon still lives near Little River, and this photograph was taken in 2008 on the steps of the head keeper's house at Point Cabrillo. (Courtesy Dan Feaster.)

Bill Owens came to Point Cabrillo in 1952 from the Point Arena Light Station, where he had been head keeper since 1937. At Point Cabrillo he supervised an USCG staff of two assistant keepers to maintain and operate the light and foghorns at the station. He was the last civilian head keeper or officer in charge in the USCG service. Owens had started out in the civilian U.S. Lighthouse Service in 1931 and continued as a civilian keeper even after the Lighthouse Service was merged into the U.S. Coast Guard in 1939. The left photograph was taken of Owens at Point Arena Light Station by another keeper, George Mattson, in 1950. The photograph below was taken at Owens's retirement ceremony at the light station in 1963 after more than 30 years as a light keeper at stations on the California coast. (Left, courtesy G. Mattson and J. Twohy; below, courtesy PCLK and the Owens family.)

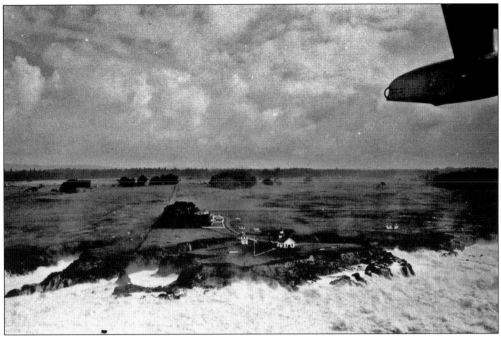

In February 1960, a series of massive Pacific storms coming out of the Gulf of Alaska created huge storm swells, which surged up onto the 50-foot-high bluffs at Point Cabrillo. This photograph was taken from a U.S. Coast Guard flying boat on patrol along the coast the morning after the storm. Head keeper Owens evacuated all the families to the east assistant keeper's house, which was the farthest building from the ocean. (Courtesy USCG.)

This photograph shows damage on the wooden siding of the western end of the lighthouse building. The inside of the building was full of rocks, boulders, and mud. The fog signal engine, visible through the doorway, had been lifted off its foundation by the powerful waves produced by the storm. (Courtesy USCG.)

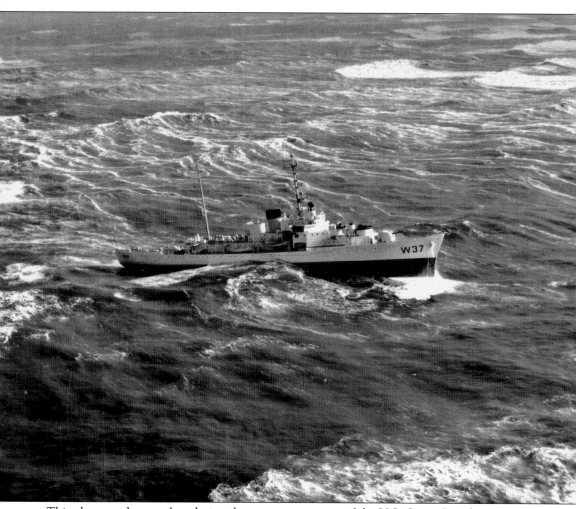

This photograph was taken during the same storm series of the U.S. Coast Guard cutter *Taney* in huge swells off the San Francisco Bar. Engineers from the Weather Service and U.S. Army Corps of Engineers estimated from the length and attitude of the cutter that the wave height must have been greater than 75 feet. This would support keeper Owens's report of seeing the rotating beams from the light at Point Cabrillo, 80 feet above sea level, reflecting off the breaking wave crests at the height of the storm. (Courtesy U.S. Naval Institute Press.)

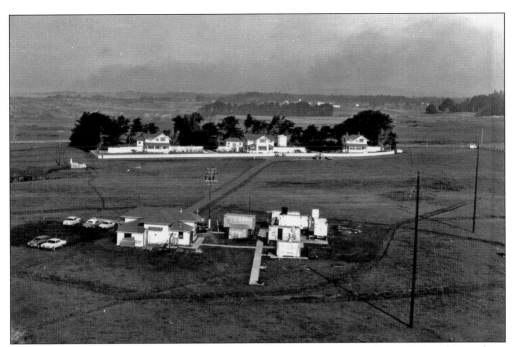

In 1962, the barn and the area around it were leased to the U.S. Air Force for a radar tracking station. Communication antennas were installed, and a number of equipment trailers surrounded the barn, which was used for office space and a bunk room for air force personnel. The air force installation was dismantled around 1972. (Courtesy USCG.)

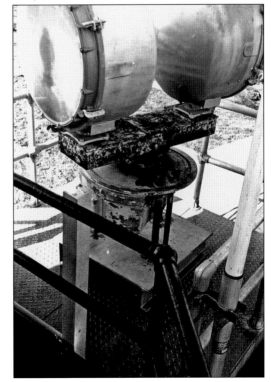

Toward the end of the 1960s, the signs became clear that the coast guard was going to automate the light station and close it as manned lighthouse. Surplus equipment was disposed of, the last remaining fog signal engine was removed, and a new DCB-224 aero-marine beacon, seen in this photograph, was installed on the roof of the fog signal building to replace the 1909 Fresnel lens. (Courtesy USCG.)

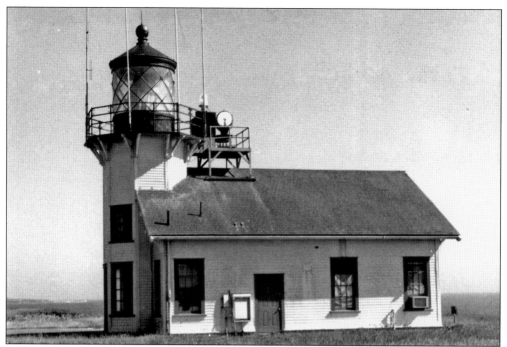

Here is another view of the lighthouse building with the DCB-224 beacon mounted on the platform on the roof of the fog signal building and seaward of the lantern room. The Fresnel lens remains in the lantern room under a protective drape. The original dormer windows seen in the earlier views of the lighthouse are missing; they were removed in an earlier reroofing of the building in the 1960s. (Courtesy U.S. Lighthouse Society.)

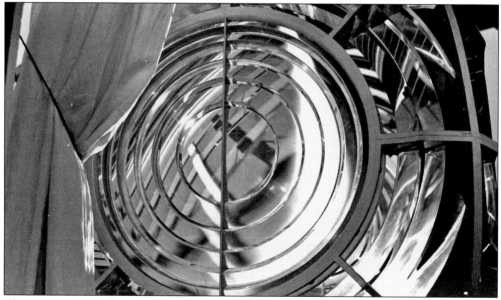

The curtain comes down on the 1909 third-order lens at Point Cabrillo in 1972 as the motor is disengaged and the lamp turned off after more than 60 years of service. The lens remained behind its drapes for 27 years, where it quietly deteriorated, unused and uncared-for, until 1998. (Courtesy USCG.)

The task of winding down operations at Point Cabrillo and decommissioning the light station fell to Chief Buck Taylor, seen in this 1968 photograph. Chief Taylor lived at the station with his wife, Frances, and their children. The houses were finally vacated in late 1972 and were boarded up by the coast guard. (Courtesy Buck and Frances Taylor.)

This is the last group of light-station children at Point Cabrillo, about 1967. The Taylor boys in this picture are, from left to right, Robert, Michael, Russell, Jeff, and Kenny. (Courtesy Buck and Frances Taylor.)

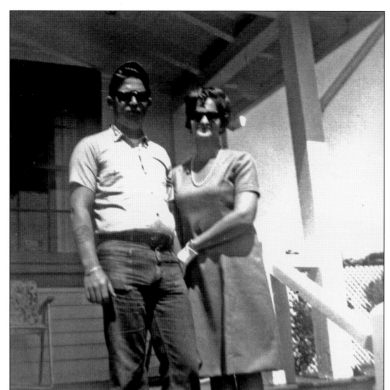

Pictured here are Buck and Frances Taylor on the steps of the head keeper's house at Point Cabrillo. Buck and Frances saved the original U.S. Lighthouse Service guest book, dating back to 1909, from being lost during the closure of the station. They brought the guest book back to Point Cabrillo in 2005, and it is now on display in the lighthouse museum. (Courtesy Buck and Frances Taylor.)

This is Buck and Frances Taylor at Point Cabrillo in 2006 beside the display case holding the original U.S. Lighthouse Service guest book, dating back to 1909. Above it is the U.S. Lighthouse Service dress cap of keeper Wilhelm Baumgartner, which was given to Point Cabrillo by descendents of Lena Baumgartner. (Courtesy PCLK.)

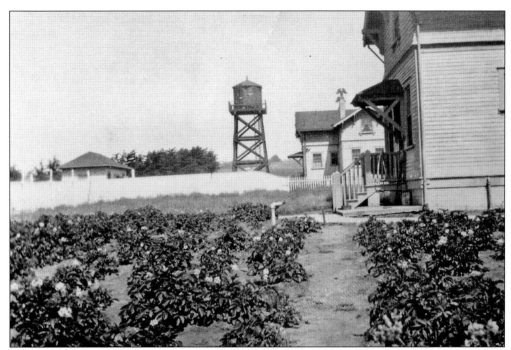

The lighthouse gardens were a major feature of light-station life at Point Cabrillo for more than 50 years. This photograph of the garden behind the head keeper's house with a large planting of potatoes was taken in the 1930s. (Courtesy U.S. Lighthouse Society.)

This is an early photograph of the gardens showing the raised flower beds at the front of the head keeper's house. (Courtesy PCLK, from the Baumgartner Family Collection.)

Sometime in the late 1970s, the houses were reopened to provide accommodations for the senior crewmembers and their families from the U.S. Coast Guard cutter *Point Ledge*, based in Noyo Harbor, Fort Bragg. This photograph shows the *Point Ledge* at the small coast guard dock in Noyo Harbor. (Courtesy USCG.)

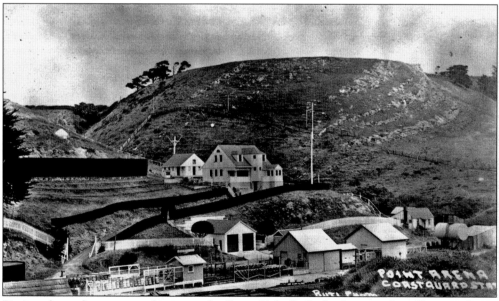

During the early coast guard years at the Point Cabrillo Light Station, the officer in charge reported to the district commander, who was based at the U.S. Coast Guard Life Boat Station at Arena Cove. This 1930s photograph shows the lifeboat station buildings in Arena Cove, south of Point Arena. (Courtesy Point Arena Lightkeepers.)

Eight

A LIGHT FOR
THE SAVING
1991–2009

In the mid-1970s, following automation of the light and decommissioning of the light station, the local community became concerned that the historic light station may be lost, and most of the privately owned surrounding land was scheduled for development for residential housing. The County of Mendocino and community activists enlisted the support of the California State Coastal Conservancy (CSCC) and local politicians to lobby for protection of the light station and surrounding lands from development and for future public ownership. Over several years, extensive negotiations took place between the CSCC and the landowners. Between 1988 and 1990, the privately owned land parcels surrounding the light station, totalling 270 acres, were acquired by CSCC. In 1991, the U.S. Coast Guard transferred the light station, exclusive of the Fresnel lens, to the CSCC under a land-exchange contract for land and new housing for the coast guard crews in Fort Bragg.

Starting in 1996, under the direction of the CSCC, all of the existing light station buildings at Point Cabrillo were restored in accordance with the secretary to the department of the interior's historic structures guidelines. Major restoration work on the historic Fresnel lens, lantern room, and fog signal building were completed between the fall of 1998 and the summer of 2001. Between 2003 and 2006, the three Craftsman-style keepers' dwellings and subsidiary buildings were extensively and adaptively restored to support the ongoing interpretive and educational programs at Point Cabrillo.

In 2002, the 30.5 acres of the light station land and buildings were transferred from the CSCC to the California State Department of Parks and Recreation, along with the surrounding 270 acres of the nature preserve. The light station is managed by the nonprofit Point Cabrillo Lightkeepers Association under a concession contract with the state parks department. In May 2008, the new park was officially designated as a State Historic Park by the California State Parks Commission and was named the Point Cabrillo Light Station State Historic Park. The park is open to the public daily from sunrise to sunset. For more details refer to the light station Web site at www.pointcabrillo.org.

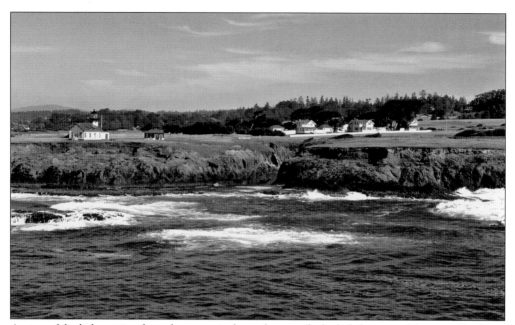

A view of the light station from the ocean is shown here, with the lighthouse and fog signal building on the left. The oil house is partially hidden behind the lighthouse. To its right is the smithy, and up the rise inland are the three keepers' houses. (Courtesy of PCLK and David Russell.)

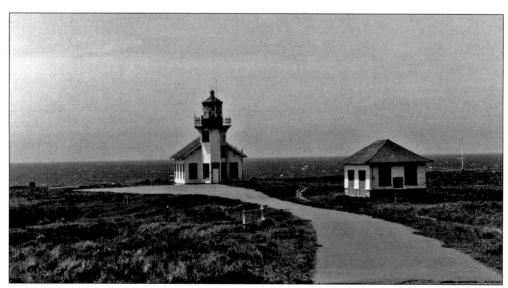

This is the smithy on the right and the lighthouse and fog signal building are behind as they appeared prior to the start of the restoration program at Point Cabrillo in 1996. (Courtesy PCLK.)

The first building to be restored by the California State Coastal Conservancy (CSCC) was the smithy in 1996. The restoration took extensive volunteer hours to remove the siding, replace rot-damaged timbers, and reattach the siding before finishing the shingles and painting the roof red. This photograph shows Point Cabrillo volunteer Art Morley working on the smithy. (Photograph by Lisa Weg, courtesy PCLK.)

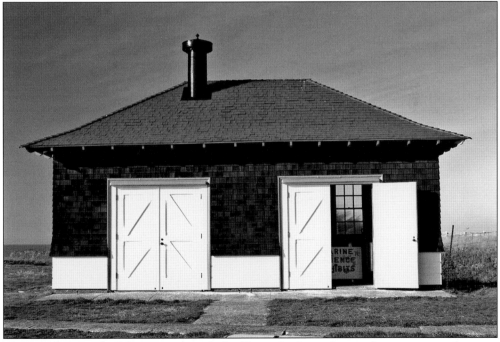

This is a photograph of the restored smithy building, which now houses the aquarium and marine science exhibits at Point Cabrillo. It is open daily for visitors, allowing them to see up close many of the local ocean flora and fauna. (Courtesy PCLK.)

U.S. Coast Guard and Point Cabrillo staff members work on dismantling the Fresnel lens in the fall of 1998. Each panel of the precious lens was carefully removed, wrapped in bubble plastic, and stored in specially made wooden boxes with additional foam padding for protection. (Photograph by David Russell, courtesy PCLK.)

The restoration team is maneuvering a lens section in its protective box on a lift platform. The team is moving it from the lantern room to the fog signal building for restoration during the winter of 1998–1999. (Photograph by David Russell, courtesy PCLK.)

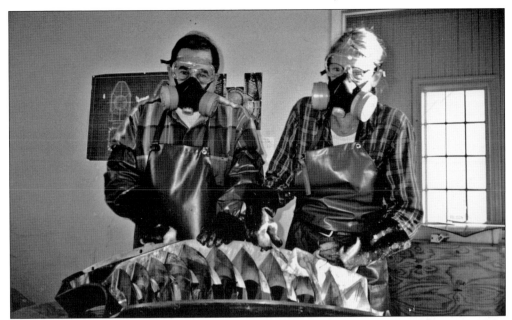

Point Cabrillo volunteers Ron Eich (left) and Ginny Chichester are shown with a section of the Fresnel lens being worked on during the winter of 1998–1999. Layers of navy gray paint had to be painstakingly removed from the brass frames using paint remover, fine tools, and toothpicks. The volunteers went through special training and had to wear protective equipment, including a mask, heavy gloves, and apron for the work. (Courtesy PCLK.)

After the lens was dismantled and safely lowered to the ground, the task of removing the lantern room was attempted by using a large crane. The first attempt had to be abandoned because of high winds but was safely completed the following day in October 1998. (Photograph by David Russell, courtesy PCLK.)

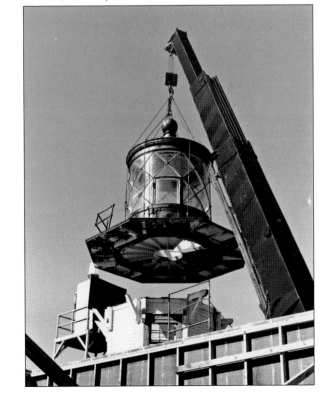

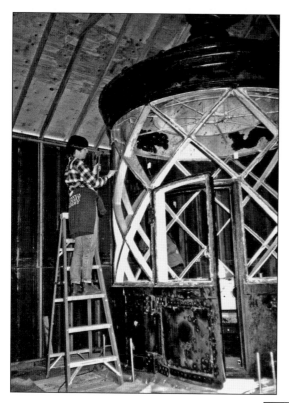

The lantern room inside a temporary protective wooden shed is being worked on by volunteer Pam Hurst. Hurst is removing the original curved diamond-shaped glass panels from the lantern room cupola. The lantern room was then cleaned of the original paints and was sand blasted. Any corroded sections were replaced, and the room was primed and painted. New glass panels were specially made to replace the old glass. (Photograph by David Russell, courtesy PCLK.)

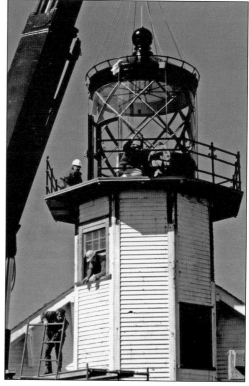

In March 1999, the fully renovated lantern room was carefully lifted back onto the light tower by a large crane. Bolting the structure to the tower had to be suspended at dusk because of high winds. Fortunately, a couple of bolts held the lantern room in place overnight until the rest of the bolts could be installed and tightened the next morning. (Photograph by David Russell, courtesy PCLK.)

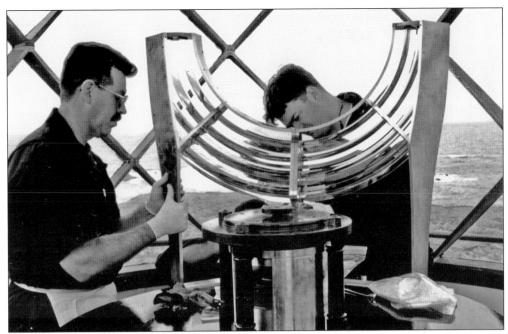

With the lantern room securely in place with its black paint shining in the spring sunshine, work started on reassembling the newly cleaned and polished sections of the Fresnel lens. This highly skilled work was done by technicians from the U.S. Coast Guard aids-to-navigation team from District 11. (Photograph by David Russell, courtesy PCLK.)

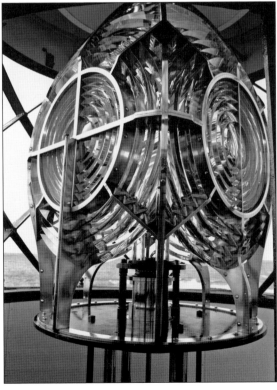

The fully assembled lens is shown in the lantern room at Point Cabrillo in late April 1999. After some final glitches and adjustments, the power switch was thrown, and the lens rumbled to life again after sitting for more than 27 years unused in the lantern room at Point Cabrillo. The light, powered by a 1000-watt bulb, began flashing its 10-second signature again. (Photograph by Bruce Rogerson, courtesy PCLK.)

On August 7, 1999, a large gathering of volunteers, staff, local residents, and dignitaries assembled for a 90th-birthday celebration for Point Cabrillo on National Lighthouse Day and the official relighting of the light in the gathering dusk of that August evening on the Mendocino coast. (Photograph by David Russell, courtesy PCLK.)

In the summer of 1999, work started on restoring the fabric of the light tower and fog signal building below the newly reinstalled lantern room and Fresnel lens. The work required was extensive and included installing the four dormer windows on the roof, which had been removed sometime in the early 1960s. This photograph shows the work underway on the roof of the fog signal building. (Photograph by Bruce Rogerson, courtesy PCLK.)

Upon the removal of the original siding, serious levels of beetle damage and dry rot were found, particularly to some of the main timbers holding up the lantern room. This required emergency repairs by the staff and contractor to reinforce the tower structure. (Courtesy PCLK.)

Volunteers at Point Cabrillo are shown painting the redwood shingles for the roof of the fog signal building. After much research, it was found that the correct color following the original U.S. Lighthouse Service specifications was Ford Model A red. With assistance from the Ford Motor Company, the correct color palette was mixed by the paint supplier for application. (Courtesy PCLK.)

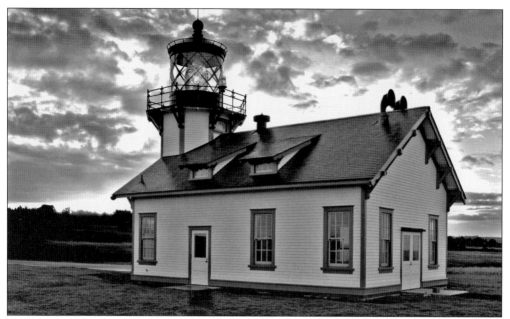

In July 2001, the restoration of the lighthouse building was finished. The period appearance of the lighthouse was set in 1935, when electricity first came to the site. The finish colors followed those specified by the Bureau of Lighthouses for the period, which included a red roof, cream siding with a pale brown trim, and a black lantern room, cupola, and deck. (Photograph by Dan Feaster, courtesy PCLK.)

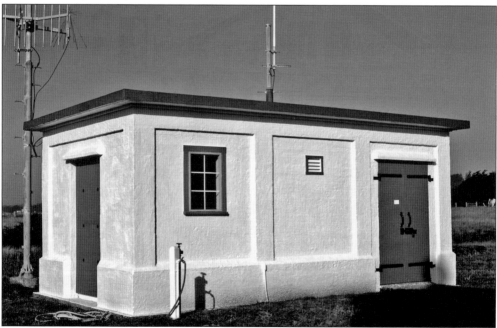

While the lighthouse was being worked on, the concrete oil house was restored and repainted with a red roof and door, and cream-colored sides. On its completion in 2000, the coast guard Loran and VHF marine radio equipment was moved from the fog signal building to the oil house, which freed up the needed space for museum exhibits and the lighthouse gift shop. (Courtesy PCLK.)

The east outbuilding is pictured here undergoing restoration in 2003. The building was in poor condition and required a new foundation, extensive replacement of damaged wood members, and a new roof. While removing the old concrete foundation, evidence of the use of gravel from the shore at Point Cabrillo was evident in the shells found. (Photograph by Bruce Rogerson, courtesy PCLK.)

The finished outbuilding behind the senior assistant keeper's house was adaptively restored to provide public restrooms for the light station visitors and was opened in late 2003. In front of the building are the first raised garden beds that were put in to continue the tradition of gardens at Point Cabrillo. (Photograph by Bruce Rogerson, courtesy PCLK.)

This is the senior assistant keeper's house as it appeared in 2003 prior to the start of restoration. Roof shingles were red but were deteriorated, with much white, peeling, lead-based paint and damaged wood members. The extensive restoration of the structure was carried out in accordance with the department of the interior guidelines for historic structures by the Point Cabrillo restoration team and outside contractors. (Photograph by Bruce Rogerson, courtesy PCLK.)

Restoration work was under way on the roof of the senior assistant keeper's house in 2004. (Photograph by Bruce Rogerson, courtesy PCLK.)

This image shows interior work on the east house. The walls and floors in the rooms were either solid old-growth Douglas-fir battens and boards or lathe and plaster construction. It required many hours of painstaking work to bring them back to their original historically correct finish. (Photograph by Bruce Rogerson, courtesy PCLK.)

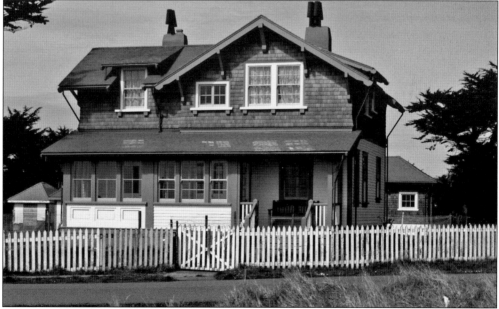

The senior assistant keeper's house is pictured as it appeared in late 2004 at the completion of the extensive restoration program. The ground floor rooms, consisting of a parlor, dining room, kitchen, and laundry room have been furnished as a keeper's museum reflecting the 1930s period, when electricity came to Point Cabrillo and the house was occupied by the keeper's family. (Photograph by Bruce Rogerson, courtesy PCLK.)

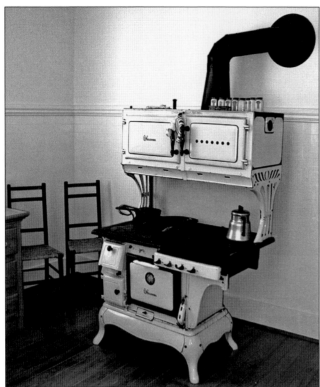

This picture of the kitchen of the restored senior assistant keeper's house shows the period coal-fired stove typical of those used in homes in the 1920s and 1930s. (Photograph by Bruce Rogerson, courtesy PCLK.)

Photographed here is the restored brick fireplace in the dining room. This is the original brick, which only required minor cleaning and re-pointing. (Photograph by Bruce Rogerson, courtesy PCLK.)

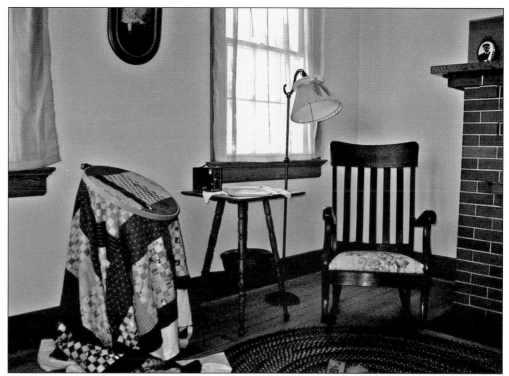

This photograph of the parlor of the senior assistant keeper's house shows the furniture used to recreate the feel of lighthouse life in the 1930s at Point Cabrillo. Many of the items displayed for today's visitors were donated by members of the local community in Mendocino and by Point Cabrillo volunteers. (Photograph by Bruce Rogerson, courtesy PCLK.)

This is the head keeper's house in 2000 prior to the start of restoration in 2005. The house has seen more than 80 years of service as the head keeper's residence in both the Lighthouse Service and U.S. Coast Guard years, as well as providing accommodations for the commanding officer of the U.S. Coast Guard cutter *Point Ledge*. (Photograph by Bruce Rogerson, courtesy PCLK.)

Work is shown under way on the head keeper's house in 2006. The restoration of this building involved stripping all the lead-based paint, extensive rehabilitation of the windows, new multi-pane windows for the watch-porch along the front of the house, new roof shingles, an update of the electrical systems, and all the functional modifications required for the building to operate as a bed-and-breakfast. (Courtesy PCLK.)

During the restoration work on the head keeper's house, the restoration team discovered a tin tobacco box hidden in the wall of the dining room between the studs. In the box was a beautiful piece of old-growth Douglas fir, which was inscribed in pencil with the signatures of Scottish workers John Finlayson of Stornoway in the Hebrides and John Marnoch of Aberdeen in 1909. The tin box was returned to its original location in the wall with the names of the 2006 restoration team added. (Courtesy PCLK.)

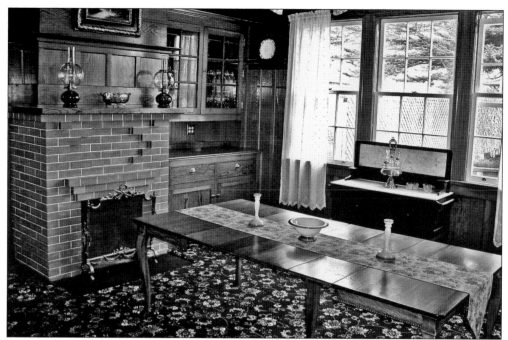

This is the finished dining room in the head keeper's house. The period furnishings were donated by community members or were acquired by the Point Cabrillo Lightkeepers Association, and many pieces were restored by volunteers and staff. The beautifully restored rooms in the head keeper's house can now be enjoyed by guests at the inn. (Photograph by Harold Hauck, courtesy PCLK.)

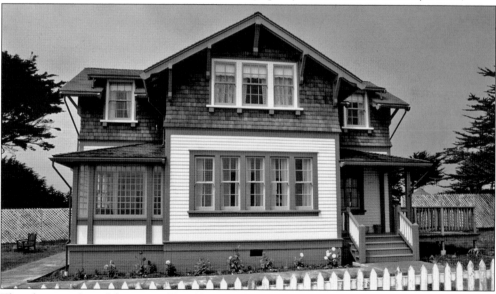

This photograph is of the restored head keeper's house, which looks as it did during the Lighthouse Service years from 1909 to 1939, with its red roof shingles, stained upper course of shingles, and light cream lower course with light brown trim. The house now operates as an inn and contains a downstairs parlor, dinning room, watch porch, kitchen, toilet, laundry room, and four guest rooms upstairs—each with a bathroom and shower. (Photograph by Rosalie Winesuff, courtesy PCLK.)

The two buildings at the rear of the head keeper's house and junior assistant keeper's house have been functionally modified to provide cottages accessible to handicapped guests at the inn, which increased the inn's capacity to six rooms. These buildings originally provided storage for coal, garden tools, and a workshop for each of the keepers at Point Cabrillo. (Photograph by Bruce Rogerson, courtesy PCLK.)

The third keeper's house, the one closest to the lighthouse, was used by the junior assistant keepers during the years of operation at Point Cabrillo. By 2007, it was showing its age and in need of serious remedial work, as can be seen in this photograph. (Photograph by Bruce Rogerson, courtesy PCLK.)

Restoration work on the exterior of the junior assistant keeper's house is shown underway in the fall of 2007. Further work is planned on the exterior and interior when additional funds can be raised. (Photograph by Bruce Rogerson, courtesy PCLK.)

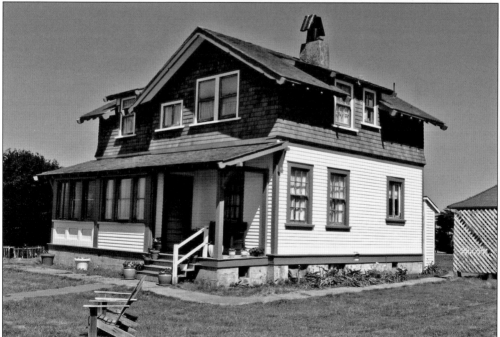

This is the junior assistant keeper's house as it appears in 2008. Future plans for the building include an additional museum about the U.S. Coast Guard years at Point Cabrillo and meeting space for volunteer programs. (Photograph by Bruce Rogerson, courtesy PCLK.)

Under the agreement with the U.S. Coast Guard to restore the light at Point Cabrillo and put the original third-order Fresnel lens back into operation as a federal aid-to-navigation, responsibility for maintaining the lens and lantern room was assigned to U.S. Coast Guard Auxiliary Flotilla 8-7 Mendocino County. This group photograph of the members of the lens maintenance team was taken in July 2007. Under the direction of the USCG Aids-to-Navigation Officer at Group Humboldt Bay, the flotilla members maintain a weekly program to clean the lantern room windows and to quarterly clean and polish the lens itself. (Photograph by Dan Feaster, courtesy PCLK.)

This photograph is of auxiliary member Tom Dolan of Fort Bragg washing the windows of the lighthouse lantern room at Point Cabrillo. (Photograph by Bruce Rogerson, courtesy PCLK.)

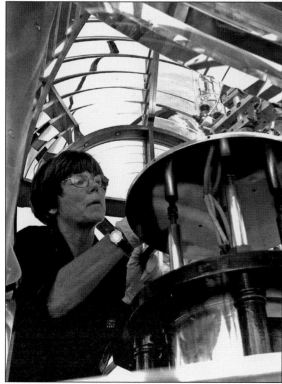

Auxiliary member Pam Hurst works inside the Fresnel lens at Point Cabrillo during cleaning time. (Photograph by Bruce Rogerson, courtesy PCLK.)

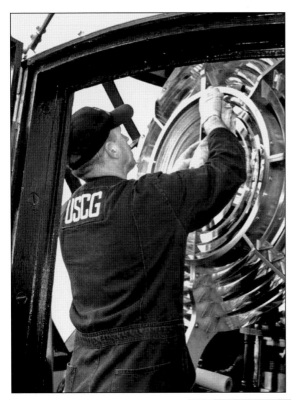

Chief Jeffrey Zappen from the USCG aids-to-navigation team at Group Humboldt Bay works on the Fresnel lens in 2007. (Photograph by Bruce Rogerson, courtesy PCLK.)

The lantern room and Fresnel lens are generally not open to light station visitors for safety reasons and to protect the lens from possible damage. However, tours of the lantern room are offered to visitors four times each year by the Point Cabrillo Lightkeepers Association, led by members of the U.S. Coast Guard Auxiliary Flotilla 8-7. The dates for these tours can be found by visiting the Point Cabrillo Web page at pointcabrillo.org. (Photograph by Bruce Rogerson, courtesy PCLK.)

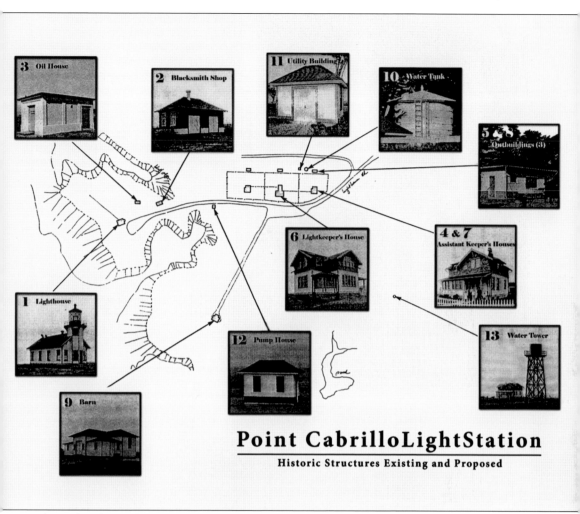

Point CabrilloLightStation

Historic Structures Existing and Proposed

This is the plan of the location of the Point Cabrillo Light Station's historic structures.

Governor's Historic Preservation Awards

November 16, 2007

Rehabilitation of Lightkeepers' Residences
Point Cabrillo Light Station

In 2007, the Point Cabrillo Lightkeepers Association, in partnership with the California Department of Parks and Recreation and the California State Coastal Conservancy, received two awards for outstanding achievements in historical preservation for the restoration of the keepers' houses at the light station, completed between 2003 and 2006. These awards are pictured here and on the next page. The Point Cabrillo Lightkeepers Association (PCLK) is a 501 (c) (3) nonprofit corporation, which operates the Point Cabrillo Light Station under a concession contract with the California Department of Parks and Recreation. Readers of this short history of the light station are encouraged to visit Point Cabrillo and experience for themselves this historic site, described as the most complete U.S. lighthouse service light station.

CALIFORNIA
PRESERVATION
F O U N D A T I O N

2007
Preservation Design Award

In Recognition of Outstanding Achievement in the

Field of Historic Preservation for the

Point Cabrillo Light Station
Restoration Project

If, after reading this history of the light station at Point Cabrillo and the truly amazing story of the light station's preservation for generations to come, you would like to help ensure the future of the light station, you are invited to join the First Century Team at Point Cabrillo. The programs for visitors, ongoing maintenance, restoration projects, fund-raising, and more all depend on the many talents and willingness to put in long hours of a small band of volunteers. Whether you can spare 5 hours or 100 hours of your valuable time, your talents can be put to work whatever they are! If becoming an active volunteer at Point Cabrillo is not your thing or if you live too far from the coast to make volunteering practical, you can still contribute to the light station's future by becoming a supporting member of the Friends of the Cabrillo Light (FOCL). The tax-deductible contributions to this program will help provide much-needed funds to sustain the many programs at Point Cabrillo. Details of the volunteer programs and membership with FOCL can be found online at www.pointcabrillo.org or can be requested by calling (707) 937-6122. Thank you from the board of the Point Cabrillo Lightkeepers Association.

BIBLIOGRAPHY

Boulé, Mary Null. *Western and Northeastern Pomo Tribes.* Vashon, WA: Merryant Publishing, 1992.

Brown, Vinson and Douglas Andrews. *The Pomo Indians of California and their Neighbors.* Healdsburg, CA: Naturegraph Publishers Inc., 1969.

Beck, Warren A. and Ynez D. Haase. *Historical Atlas of California.* Norman, OK: University of Oklahoma Press, 1974.

Caranan, Jill. *American Lighthouses.* Todtri Productions, 1996.

Dana, Richard Henry. *Two Years before the Mast.* New York: Westvaco, 1992.

De Wire, Elinor. "Point Cabrillo Lighthouse," NOAA Weather Log, 1993.

Everett, Richard. "Found! The Wreck of the Frolic," *San Francisco Maritime Museum Magazine.*

Grant, John and Ray Jones. *Legendary Lighthouses.* Guilford, CT: Globe Pequot Press, 1998.

Gibbs, Jim. *Lighthouses of the Pacific.* West Chester, PA: Schiffer Publishing, 1986.

Hayes, Derek. *Historical Atlas of California.* Berkeley, CA: University of California Press, 2007.

Layton, Thomas N. *The Voyage of the Frolic.* Stanford, CA: Stanford University Press, 1997.

———. *Gifts from the Celestial Kingdom.* Stanford, CA: Stanford University Press, 2002.

Mendocino Coast Volumes I and II. *Fort Bragg Advocate,* 1995 and 1999.

McNairn, Jack and Jerry MacMullen. *Ships of the Redwood Coast.* Stanford, CA: Stanford University Press, 1945.

McIver, Julia. "How the Headland was Won," *California Coast and Ocean,* 1992.

Nauman, James D., ed. *An Account of the Voyage of Juan Rodriguez Cabrillo.* Cabrillo National Monument Foundation, 1999.

Owens, Cora Isabel. "Point Cabrillo Lighthouse Memories," *The Keepers Log,* 1990.

Paddison, Joshua, ed. *A World Transformed: First Hand Accounts of California before the Gold Rush.* Berkeley, CA: Heyday Books Press.

Polk, Dora Beale. *The Islands of California: A History of the Myth.* Lincoln: NE: University of Nebraska Press, 1971.

Point Cabrillo docent notes, 1998 and 2002.

Roberts, Bruce and Ray Jones. *California Lighthouses.* Old Saybrook, CT: Globe Pequot Press, 1997.

Rogerson, Bruce. "Point Cabrillo Light Station," *The Keepers Log,* 2007.

Shanks, Ralph and Lisa Woo Shanks. *Guardians of the Golden Gate.* Petaluma, CA: Costano Books, 1990.

Trott, Harlan. *The Schooner Comes Home.* Cambridge, MD: Cornel Maritime Press, 1958.

Wilcox, Del. *Voyagers to California.* Sea Rock Press, 1991.

Watson, Bruce. "Science Makes a Better Lens," *Smithsonian,* 1990.

Wheeler, Wayne. "Augustin Fresnel and His Magic Lantern," *The Keeper's Log,* 1985.

INDEX

ACROSS AMERICA, PEOPLE ARE DISCOVERING SOMETHING WONDERFUL. *THEIR HERITAGE.*

Arcadia Publishing is the leading local history publisher in the United States. With more than 4,000 titles in print and hundreds of new titles released every year, Arcadia has extensive specialized experience chronicling the history of communities and celebrating America's hidden stories, bringing to life the people, places, and events from the past. To discover the history of other communities across the nation, please visit:

www.arcadiapublishing.com

Customized search tools allow you to find regional history books about the town where you grew up, the cities where your friends and family live, the town where your parents met, or even that retirement spot you've been dreaming about.